7/94

SIGNS FROM THE HEART:
California Chicano Murals

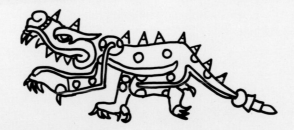

**Edited with an introduction by
Eva Sperling Cockcroft and Holly Barnet-Sánchez**

**Social and Public Art Resource Center, Venice, California
University of New Mexico Press, Albuquerque**

Cover: *Las Lechugueras,* 1983, Juana Alicia. 2794 24th St., Mission District, San Francisco. Total mural 30′ × 50′, photo: Tim Drescher.

Book design by Cynthia Anderson and Christienne de Tournay

Funded in part by: Ahmanson Foundation, ARCO Foundation, California Community Foundation, California Council on the Humanities, McDonnell-Douglas, Lear Siegler Foundation, Pacific Bell Corporation, National Endowment for the Arts, Visual Arts, and University of California at Irvine, Fine Arts Department.

Library of Congress Cataloging-in-Publication Data

Signs from the heart: California Chicano murals / edited with an introduction by Eva
 Sperling Cockcroft and Holly Barnet-Sánchez.
 p. cm.
 Originally published: Venice, Calif.: Social and Public Art Resource Center, 1990.
 Includes bibliographical references and index.
 ISBN 0-8263-1448-1
 1. Street art—California. 2. Mural painting—20th century—California.
3. Mexican Americans—California—Politics and government—Pictorial works.
I. Cockcroft, Eva Sperling. II. Barnet-Sánchez, Holly. III. Social and Public Arts
Resource Center (Venice, Los Angeles, Calif.)
ND2635.C2S56 1993
751.7′3′08968720794—dc20 93-17526
 CIP

*T*his book can be seen as the fulfillment of a dream begun in 1974 when the first slide was collected of the Archive of the Social and Public Art Resource Center (SPARC). This process, which began among muralists as one collects pictures for a family album to record memories, changed as we realized we were in the midst of something important. As the Chicano artist community became increasingly committed to the goals of the Chicano Movement, the purpose of our communal work became clearer. What had begun as a casual recording of our murals to share and exchange would soon outgrow its picture taking phase and become the basis of nationwide photo documentation of a powerful community based art. While the Chicano collection represents only one part of SPARC's larger collection of international mural slides, it is an extremely significant one as Chicano murals have influenced international muralism greatly and contributed to the shift in emphasis from Mexico to the United States as the center of mural production in the world.

We are now at a juncture where we can bring together this photographic documentation with essays by scholars on Chicano muralism in California, its artists, its imagery, and its social and historical development. As one of the "cultural workers" of the early Chicano Movement, I recall our desire to develop a new visual language which spoke from our own cultural precedents in pre-Columbian art and our experience of contemporary popular Chicano culture. What was appropriate visual language was the subject of considerable intellectual (and not so intellectual) debate among us. The hundreds of murals produced in Mexican-American neighborhoods across the country attest to the realization of a personal and collective voice, as

well as an achieved identity. As artists we joined with young Chicanos and Chicanas to transform public spaces to reflect the people who used them. This book is a continuation of this process as it opens up a new level of communication between those communities and the larger society.

SPARC began as the support group to its predecessor, the Citywide Mural Program, which under the auspices of the City of Los Angeles Department of Recreation and Parks sponsored within its first two years of existance 40 murals a year in diverse communities of Los Angeles. Many of these communities were Chicano as was the staff of the program. Over ten years 250 murals were sponsored by this first Los Angeles community murals program.

Since 1976 SPARC has been providing leadership in areas where art and social resources can work together to enhance our understanding and appreciation of the importance of this country's diversity. As a community arts center with a committment to positive social change and a multi-cultural focus, SPARC has played an important role in exhibiting and producing public artworks, especially wall paintings that include a participatory process. We believe that positive gains can be achieved by making educational cultural affirmation available to everyone, especially to those communities or segments of our society which do not generally receive positive image reinforcements through the media and elsewhere.

For this reason, in addition to maintaining a standard of artistic excellence, our murals have emphasized community participation. The 2,435 foot long, *Great Wall of Los Angeles*, included the participation of 215 youths. Our current program, begun in 1988, *Neighborhood Pride: Great Walls Unlimited* commissions artists to work with local youths in painting murals throughout the city. Because of our committment to education, SPARC also houses the Mural Resource Center which serves as a reference, research and slide distribution center for the study of murals. In 1984, SPARC embarked upon a documentation project of Chicano murals in California directed by Kate Vozoff and Max Benavides which features approximately 4,000 slides, one set of which is housed at SPARC and the other at the Smithsonian's Archive of American Art in San Marino. This book was begun in 1986 as a result of that documentation project with the intention of educating young Chicanos about their heritage, and the general public about the artistic genre of Chicano murals.

This book would not have been possible without the dedication, scholarship and perseverance of the editors and authors, their commitment to the Chicano community, and their sensitivity to its art and artists. I would especially like to thank the editors, Eva Cockcroft and Holly Barnet-Sánchez. I would also like to thank those organizations who believed in the project enough to fund it: The Ahmanson Foundation, Arco Foundation, California Community

2

Foundation, California Council on the Humanities, McDonnell-Douglas, Lear Siegler Foundation, Pacific Bell Corporation, Professor Roberto Garfias and the Fine Arts Department of the University of California at Irvine, and the Visual Arts Program of the National Endowment for the Arts.

 As the first in a proposed series of books on public art, it is hoped that this book will serve to clarify for students and educators as well as for ourselves the meaning of these murals as "signs from the heart."

Judith F. Baca
1989, Los Angeles
Artistic Director,
Social and Public Art Resource Center

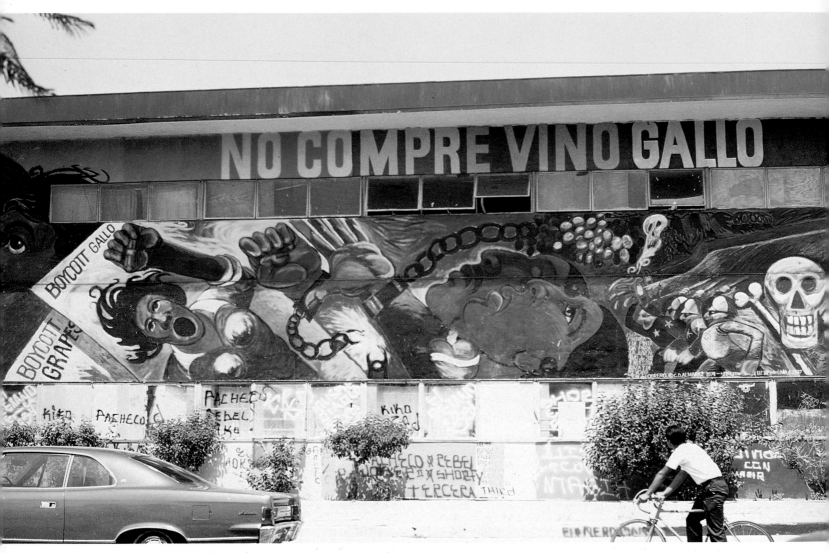

NO COMPRE VINO GALLO
1974
Carlos Almaraz with young people from the 3rd St. gang
213 South Soto St. formerly All Nations Center, East Los Angeles
8' x 30'

A truly "public" art provides society with the symbolic representation of collective beliefs as well as a continuing re-affirmation of the collective sense of self. Paintings on walls, or "murals" as they are commonly called, are perhaps the quintessential public art in this regard. Since before the cave paintings at Altamira some 15,000 years before Christ, wall paintings have served as a way of communicating collective visions within a community of people. During the Renaissance in Italy, considered by many to be the golden age of Western Art, murals were regarded as the highest form in the hierarchy of painting. They served to illustrate the religious lessons of the church and to embody the new Humanism of the period through artistic innovations like perspective and naturalistic anatomy.

After the Mexican Revolution of 1910-1917, murals again served as the artistic vehicle for educating a largely illiterate populace about the ideals of the new society and the virtues and evils of the past. As part of a re-evaluation of their cultural identity by Mexican-Americans during the Chicano movement for civil rights and social justice that began in the mid-1960s, murals again provided an important organizing tool and a means for the reclamation of their specific cultural heritage.

The desire by people for beauty and meaning in their lives is fundamental to their identity as human beings. Some form of art, therefore, has existed in every society throughout history. Before the development of a significant private picture market in Seventeenth Century Holland, most art was public, commissioned by royalty, clergy, or powerful citizens for the greater glory of their country, church, or city and placed in public spaces. However, after the Industrial Revolution and the development of modern capitalism with its stress on financial rather than social values, the art world system as we know it today with galleries, critics, and

5

museums gradually developed. More and more, art became a luxury object to be enjoyed and traded like any other commodity. The break-up of the stable structures of feudal society and the fluidity and dynamism of post-Industrial society was reflected symbolically in art by the disruption of naturalistic space and the experimentation characteristic of Modernism.

Modernism has been a mixed blessing for art and artists. Along with a new freedom for innovation and the opportunity to express an individual vision that resulted from the loss of direct control by patrons of artistic production, artists experienced a sense of alienation from the materialistic values of capitalism, loss of a feeling of clearly defined social utility, and the freedom to starve. This unstable class situation and perception of isolation from society was expressed in the attitude of the bohemian *avant garde* artist who scorns both the crass commercialism of the bourgeoisie and the unsophistocated tastes of the working class, creating work exclusively for the appreciation of a new aristocracy of taste. Especially in the United States of the 1960s, for most people art had become an irrelevant and mysterious thing enjoyed only by a small educated elite.

When muralism emerged again as an important art movement in Mexico during the 1920s, the murals served as a way of creating a new national consciousness — a role quite similar to that of the religious murals of the Renaissance although directed toward a different form of social cohesion. Unlike the murals of the Italian Renaissance which expressed the commonly held beliefs of both rulers and masses, the Mexican murals portrayed the ideology of a worker, peasant and middle class revolution against the former ruling class: capitalists, clergy, and foreign interests. Since that time in the eyes of many, contemporary muralism has been identified with poor people, revolution, and communism. This association has been a major factor in changing muralism's rank within the hierarchy of the "fine arts" from the highest to the lowest. Once the favored art of popes and potentates, murals, especially Mexican-style narrative murals, now considered a "poor people's art", have fallen to a level of only marginal acceptance within the art world.

The three great Mexican artists whose names have become almost synonymous with that mural renaissance, Diego Rivera, Jose Clemente Orozco, and David Alfaro Siqueiros, were all influenced by stylistic currents in European modernism — Cubism, Expressionism, and Futurism — but they used these stylistic innovations to create a new socially motivated realism. Rather than continuing to use the naturalistic pictorial space of Renaissance murals, the Mexicans explored new forms of composition. Rivera used a collage-like discontinuous space which juxtaposed elements of different sizes; Orozco employed non-naturalistic brushwork, distorted forms, and exaggerated light and dark, while Siqueiros added expressive uses of

perspective with extreme foreshortening that made forms burst right out of the wall. The stylistic innovations of the Mexicans have provided the basis for a modern mural language and most contemporary muralism is based to some extent or another on the Mexican model. The Mexican precedent has been especially important in the United States for the social realist muralists of the Works Progress Administration (WPA) and Treasury Section programs of the New Deal period and the contemporary mural movement that began in the late 1960s.

More than 2500 murals were painted with government sponsorship during the New Deal period in the United States. By the beginning of World War II however, support for social realist painting and muralism in general, had ended. During the Cold War period that followed, realistic painting became identified with totalitarian systems like that of the Soviet Union, while abstraction, especially New York-style Abstract Expressionism, was seen as symbolizing individual freedom in *avant garde* art circles. By the early 1960s, only the various kinds of abstract art from the geometric to the bio-morphic were even considered to really be art. Endorsed by critics and the New York museums, abstraction was promulgated abroad as the International Style and considered to be "universal" — in much the same way as straight-nosed, straight-haired, blondes were considered to be the "universal" ideal of beauty. Those who differed or complained were dismissed as ignorant, uncultured, or anti-American.

The concept of a "universal" ideal of beauty was closely related to the "melting pot" theory, then taught in schools, which held that all the different immigrants, races and national groups which composed the population of the United States could be assimilated into a single homogeneous "American". This theory ignored the existance of separate cultural enclaves within the United States as well as blatant discrimination and racism. It also ignored the complex dialectic between isolation and assimilation and the problem of identity for people like the Mexican-Americans of California who were neither wholly "American" nor "Mexican" but a new, unique, and constantly changing composite variously called "American of Mexican descent," "Mexican-American," Latino or Hispanic. In the 1960s the term "Chicano" with its populist origins was adopted by socially-conscious youth as a form of positive self-identification for Mexican-Americans. Its use became a form of political statement in and of itself.[1]

The dialectic between assimilation and separatism can be seen in the history of Los Angeles, for example, first founded in 1781 as a part of New Spain. In spite of constant

1. Throughout this book several terms will be used to identify Americans of Mexican descent: "Mexican-Americans," "U.S. Mexicans," and "Chicanos." Each carries specific meanings and are not used interchangeably. "Mexican-American" is primarily a post World War II development in regular use until the politicization of *el movimiento*, the Chicano civil rights movement of the 1960s and 1970s. Its use acknowledges with pride the Mexican heritage which was hidden by an earlier, less appropriate term,

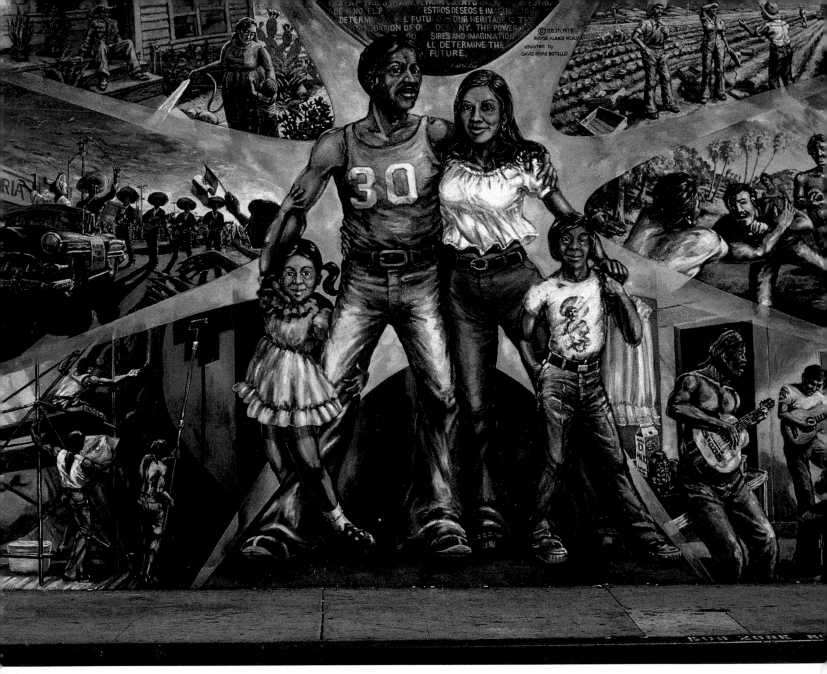

"La Familia" from *CHICANO TIME TRIP*
1977
East Los Streetscapers (Wayne Alaniz Healy and David Rivas Botello)
Lincoln Heights, East Los Angeles,
total mural 18' x 90', this panel 18' x 26'
A Citywide mural project.

pressure for assimilation including job discrimination and compulsory use of English in the schools, the Mexican-American population was able to maintain a culture sufficiently distinct so that, as historian Juan Gómez-Quiñones has frequently argued, a city within a city can be defined. This separate culture continues to exist as a distinct entity within the dominant culture, even though it is now approximately 150 years since Los Angeles was acquired by the United States. This situation, by itself, tends to discredit the melting pot concept.

The Civil Rights Movement, known among Mexican-Americans as the Chicano Movement or *el movimiento*, fought against the idea of a "universal" culture, a single ideal of beauty and order. It re-examined the common assumption that European or Western ideas represented the pinnacle of "civilization," while everything else, from the thought of Confucius to Peruvian portrait vases, was second-rate, too exotic, or "primitive." The emphasis placed by Civil Rights leaders on self-definition and cultural pride sparked a revision of standard histories to include the previously unrecognized accomplishments of women and minorities as well as a re-examination of the standard school curriculum. Along with the demonstrations, strikes, and marches of the political movement came an explosion of cultural expression.

As was the case after the Mexican Revolution, the Civil Rights Movement inspired a revival of muralism. However, this new mural movement differed in many important ways from the Mexican one. It was not sponsored by a successful revolutionary government, but came out of the struggle by the people themselves against the *status quo*. Instead of well-funded projects in government buildings, these new murals were located in the *barrios* and ghettos of the inner cities, where oppressed people lived. They served as an inspiration for struggle, a way of reclaiming a cultural heritage, or even as a means of developing self-pride. Perhaps most significantly, these murals were not the expression of an individual vision. Artists encouraged local residents to join them in discussing the content, and often, in doing the actual painting. For the first time, techniques were developed that would allow non-artists working with a professional to design and paint their own murals. This element of community participation, the placement of murals on exterior walls in the community itself, and the philosophy of community

"Spanish-American." However, it's hyphenated contruction implies a level of equality in status between the Mexican and the American which in actuality belies the unequal treatment of Americans of Mexican descent within United States society.

U. S. Mexican is a term developed by essayist Marcos Sanchez-Tranquilino to replace the term Mexican-American with one that represents both more generally and clearly all Mexicans within the United States whether their families were here prior to annexation in 1848, have been here for generations, or for only two days. In other words, it represents all Mexicans living within U. S. borders regardless of residence or citizenship status.

The most basic definition of the term Chicano was made by journalist Ruben Salazar in 1970: "A Chicano is a Mexican-American who does not have an Anglo image of himself." It is a term of self-definition that denotes politicization.

input, that is, the right of a community to decide on what kind of art it wants, characterized the new muralism.

Nowhere did the community-based mural movement take firmer root than in the Chicano communities of California. With the Mexican mural tradition as part of their heritage, murals were a particularly congenial form for Chicano artists to express the collective vision of their community. The mild climate and low, stuccoed buildings provided favorable physical conditions, and, within a few years, California had more murals than any other region of the country. As home to the largest concentration of Mexicans and people of Mexican ancestry anywhere outside of Mexico City, Los Angeles became the site of the largest concentration of Chicano murals in the United States. Estimates range from one thousand to fifteen hundred separate works painted between 1969 and the present. The Social and Public Art Resource Center's "California Chicano Mural Archive" compiled in 1984 documents close to 1000 mural projects throughout the state in slide form.

All art has a relationship to the social structures and political events of the society in which it is created that is found in both content and form. For most art, this relationship is fairly indirect. However, public art (and in particular mural art) is more directly tied to political and economic structures and social imperatives. Muralism, unlike easel painting, requires substantial patronage in the form of funds and public support in order to flourish. Traditionally, this support came from wealthy individuals and official institutions like the government or the church. In the contemporary mural movement, the situation has been more complex.

Support can come entirely from grass-roots sources, neighborhood, labor, or issue-oriented groups. It can also come directly from government sources — as in city-sponsored programs or State and Federal Arts Endowment grants — or indirectly through social service, job training, and employment programs. Corporate, foundation, and individual grants, although important, generally play a more minor role. Almost always, the amount of funding is closely tied to levels of social unrest and/or political pressure. Thus, in California, the early level of support for murals was directly related to the impact of the massive Chicano mobilization of *el movimiento* while the current revival of support corresponds to concerns about high levels of gang and drug violence coupled with the increased power of Latinos, in general, as a consumer and voting bloc. Other, more ideological factors include levels of political consciousness and community involvement on the part of artists and intellectuals, art world trends, and the general social atmosphere as represented through the media.

Changes in the themes, frequency and type of murals painted are determined by specific combinations of social and economic factors. In the early period of Chicano muralism,

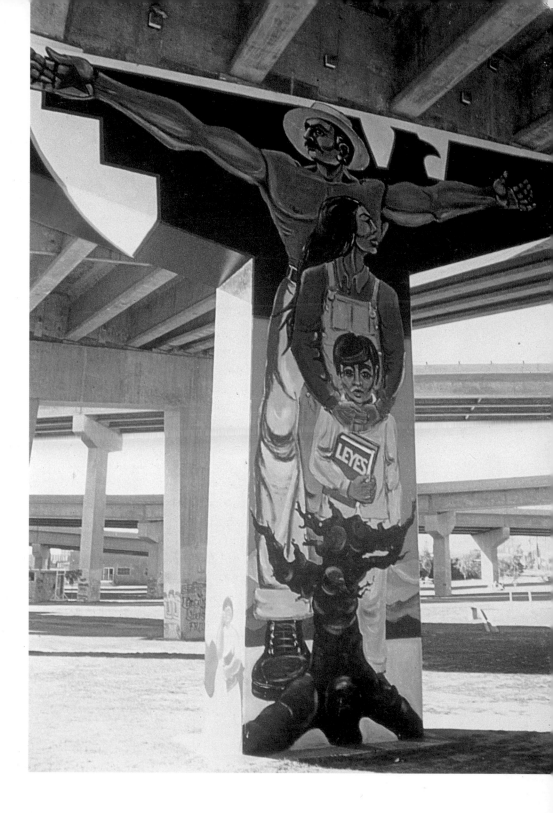

CHICANO PARK
FREEWAY PYLON
1975
José Montoya and
the Royal Chicano Air Force
Chicano Park, San Diego
30' x 35'

from 1969-1975, during the height of political activism, most murals had mainly grass-roots sponsorship through political and neighborhood groups, artist-initiated community arts centers, local merchants, and self-funding by the artists. Themes tended to reflect the nationalistic concerns of the times and dealt largely with questions of Chicano identity.

By the mid- to late 1970s, however, murals had been accepted by government as an inexpensive means of urban revitalization and constructive youth activity. Art world authorities saw street murals as an interesting new form. As early as 1974, a group of Chicano artists, Los Four, were given an exhibition at the L. A. County Museum that included examples of their murals. Increasingly, funding for murals came from official rather than grass-roots sources through federal, state, and city programs as well as corporate and foundation grants. The formerly artist-run community arts centers began to hire administrators as fund-raising and grant writing became more important elements within the organizations. Two national conferences of community muralists in 1976 and 1978 increased communication between artists from different areas of the country and different ethnic and racial groups. Several books about murals, two of them written by participants in the mural movement, *Toward a Peoples Art: The Contemporary Mural Movement* and *The Mural Manual* were published in the mid-1970s. To some extent, these served as extensive, documented manifestos which systematized the philosophy of community murals, designated major artists, and helped spread the movement internationally. By the second national conference, in 1978, there was a significant participation by community muralists from England, France, Scotland and Mexico. As a result of this conference an international newsletter (later the quarterly magazine, *Community Murals*) began publication and continued to publish regularly until 1988.

The ideology and implementation of community participation in public art developed by the mural movement also influenced "official" public art in the United States. First, a debate within the art community on the legitimacy of "private" images in "public" spaces was initiated. Eventually, at least the language of community control and participation became part of the accepted formula in commissioning public art. Perhaps most important, interest generated by street murals created a new impetus toward government responsibility for commissioning public art that has been influential in the formation of the numerous Percent for Art programs in cities around the nation.

Recognition and institutionalization had several effects on both the form and content of Chicano murals. While numerous artists had participated briefly in the spontaneous outpouring of murals during *el movimiento*, by the mid-1970s certain artists began to be identified and identify themselves as mural artists. Concerns about permanence, composition, formal

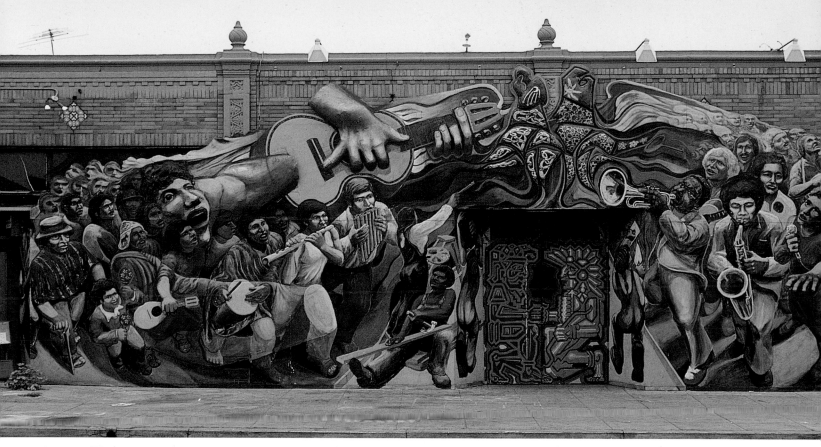

SONG OF UNITY
1978
Commonarts (Ray Patlán, Osha Neumann, Anna de Leon, O'Brian Thiele)
La Peña Cultural Center, 3105 Shattuck Ave., Berkeley
approx. 20' x 50'.

experimentation and aesthetic quality became as important to muralists as the immediate political or organizing impact. In thematic terms as well, serious muralists developed beyond the identity question to grapple with more general themes. Traditional handling of symbols that had dominated many of the early walls, such as the farmworkers flag, the Virgin of Guadalupe, and pre-Columbian imagery, began to seem old-fashioned and clichéd as new social as well as artistic issues and concerns confronted the artists.

Institutionally as well, the nationalist phase of the mural movement had ended. Los Angeles' Citywide Murals program, for example, which began in 1974, although headed by Chicana muralist Judy Baca, sponsored 250 murals throughout Los Angeles by Anglo, Asian and Black artists as well as Chicanos. Baca's next project carried this multi-ethnic idea even further. the *Great Wall of Los Angeles* mural, a history of minorities in California painted in a flood control channel, was begun in 1976 by a racially and ethnically mixed group of 10 artists and some 80

13

teenagers under the direction of Baca. Even one of the most militantly grass roots and nationalist examples of the major mural projects, San Diego's *Chicano Park* (the painted pillars beneath the Coronado Bay Bridge that began with a land takeover in 1970), integrated non-Chicanos into its 1977 "Muralthon." In the Bay Area, Ray Patlán, a leading Chicano artist, joined with three other artists to form the multi-ethnic collective Commonarts which created the classic *Song of Unity* mural in honor of the victims of the Pinochet dictatorship in Chile and indigenous cultural expression in North and Latin America. More and more the identification became "minority" or "oppressed" rather than strictly "Chicano".

The largest expansion of contemporary muralism in the United States came in the late 1970s when funds from the Carter Administration job training program (CETA), became widely used to hire artists and create community arts programs in cities around the country. Described as a smaller version of the New Deal artist employment programs, CETA introduced hundreds of young artists to muralism bringing public art to the "heartland" for the first time since the 1930s. The prominence of local government in these programs, however, created an implicit (and sometimes real) threat of censorship that tended to dilute the content of these walls. The depoliticization of muralism in the late 1970s also corresponded to decreased social activism after the end of the Vietnam crisis.

After CETA, many critics declared that the mural revival was finished. Ironically, however, the Reagan years have witnessed renewed vitality, not only in muralism and Chicano art, but also in realism and socially conscious art in general. The growth of the ultra-conservative religious right coupled with fears of U.S. military involvement in Central America created new activism at the grass roots level during the 1980s. At the same time, there has been greater recognition for Chicano art and murals within mainstream institutions which has created new opportunities for Chicano artists. Additionally, the buying and voting power of the rapidly growing Latino population of the United States has provided new recognition for Chicano concerns and Latino cultures in general.

The 1980s have witnessed an explosion of major national exhibitions of Latin American and "Hispanic" art that have toured the nation including "Diego Rivera," "Art of the Fantastic," "Hispanic Art in the United States," and "Latin American Spirit." "Chicano Art: Resistance and Affirmation, 1965-1985," an interpretive exhibition examining the relationship between the Chicano civil rights movement and the Chicano art movement, opened in 1990. Many of the young rebels who initiated the Chicano mural movement have explored and continued to develop other media in addition to muralism: easel painting, sculpture, assemblage, installation, performance, and video. Many have been given museum exhibitions and achieved

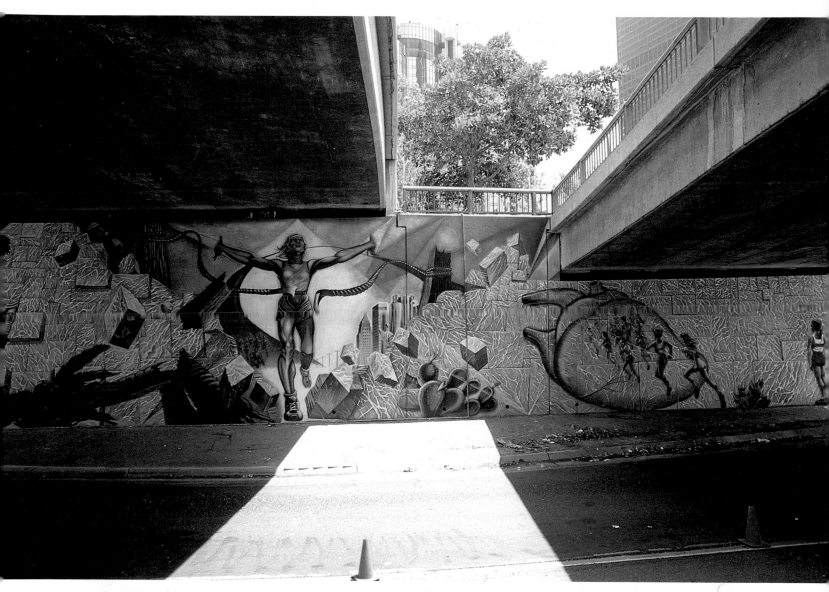

HITTING THE WALL
1984
Judith F. Baca
Harbor Freeway, Los Angeles
18' x 90'

national reputations. This success has not necessarily meant a denial of their heritage or their activism as it might have before 1969. San Diego's Border Art Workshop, for example, formed in part by veterans of the Centro Cultural de la Raza/Chicano Park murals, was invited to show installations and performance pieces dealing with the plight of migrant workers and other border issues at the prestigious Artists Space gallery in New York City in 1989. Their art is able to cross-over into the mainstream in spite of the strong political content because of the artistically innovative format of their installations. While almost all Chicano artists today participate in gallery exhibitions, and for some this is their major emphasis, others have continued to concentrate on their work with the community and as muralists.

Over the years, the city of Los Angeles has come to identify itself as the mural capital of the world. During the Los Angeles Olympics in 1984, the city commissioned a series of ten freeway murals from the leading local mural artists, three of whom are Chicanos: Judy Baca, Willie Herrón, and Frank Romero. There were a number of unofficial pieces as well, including a large downtown wall by the East Los Streetscapers. The city of San Francisco has also continued to provide significant patronage for Chicano muralists. Since 1988, there is also a active program in Los Angeles begun by artists, for the restoration and preservation of landmark murals — some close to twenty years old. Between 1988-89, SPARC's mural restoration program, the Mural Emergency Relief Fund, has already made eight small grants to artists to restore their damaged murals. Beginning in 1988, the city of Los Angeles again became active as a patron of murals in the various council districts of the city through the *Neighborhood Pride: Great Walls Unlimited* program. Administered by SPARC and modeled after the precedent established in the *Great Wall* program for community participation murals, *Neighborhood Pride* commissioned nine murals in 1988-1989 and has fifteen more scheduled for 1989-90.

The following four essays are devoted to the discussion and analysis of the historical and social relationships through which Chicanos have used culture, and in particular murals, to explore their individual and collective identity. The first essay, by art historian and critic, Shifra Goldman, "How, Why, Where, and When it all Happened: Chicano Murals of California," provides a comprehensive history of Chicano murals and an informed discussion of the diverse elements that comprise the Chicano mural movement. In it she proposes several categories which make the California material more accessible, examining the work in terms of period, region, subject, and organizational structures. Goldman develops a chronology of public muralism in the 1970s and 1980s providing an important tool for locating this art movement within its historical and art historical contexts. She also analyzes the themes and specifically Chicano iconography developed by the muralists, indicating the special meaning these images

had for the artists during the period when the work was painted. In addition, this essay examines the changing nature of political activity and social consciousness as they affected mural content and patronage and looks toward the present status of the mural movement.

The second essay by cultural historian Tomás Ybarra-Frausto, "*Arte Chicano: Images of a Community*," identifies Chicano art as a historically evolving social process informed, sustained and directed by the community-based construction of a Chicano cultural identity. According to Ybarra-Frausto, to be Chicano/a requires the assertion of one's self as an integral component of the Chicano community. This affiliation is based on the recognition of a shared living experience as Mexicans (and their descendents). In the United States, this identity is rooted economically in the Mexican-American working class, supported generationally and extended geographically by way of Chicano *barrios*. These *barrios* were and continue to be an important link in a network basic to the exchange of cultural influences both within and between regions. Thus, long-established communal rituals, such as those followed by the *penitentes* religious group, and traditional arts, such as the wooden sculptures of *santos* (saints) made regionally by the *santeros*, provided precedents for communal and performative aspects of Chicano art. In the 1970s these residual forms and practices found an extension of their traditional audience as *barrio* networking reconnected them to emergent national forms of Chicano art.

Because Chicano artists were consciously searching to identify the images that represented their shared experience they were continually led back to the *barrio*. It became the site for "finding" the symbols, forms, colors, and narratives that would assist them in the re-definition of their communities. Not interested in perpetuating the Hollywood notion that art was primarily an avenue of escape from reality, Chicano artists sought to use their art to create a dialogue of demystification through which the Chicano community could evolve toward cultural liberation. To this end, murals and posters became an ubiquitous element of the *barrioscape*. According to Ybarra-Frausto, they publicly represented the reclamation of individual Chicano minds and hearts through the acknowledgement and celebration of their community's identity through the creation of an art of resistance.

Amalia Mesa-Bains examines the issues of muralism from a different perspective than the other authors in "Quest for Identity: Profile of Two Chicana Muralists." She offers insight into the interdependence between personal and collective experience in the development of self-identity for both the individual artist and the community as a whole. For those artists who "came of age" within the Chicano Movement, the relationship each had with their community was intensified. This was due to the fact that their home environment, specifically the shared day to day living experience in the *barrio*, had become a "cultural sanctuary" from which they drew

17

not only material for their art but also the personal strength neccessary for leadership. These artists transformed items of personal and familial identity into a public image signifying resistance. This was especially important for women artists within the Chicano movement, for whom the struggle for liberation as part of an oppressed national community coalesced with that of personal liberation within the family.

In the two cases described by Mesa-Bains of Judy Baca and Patricia Rodríguez, both artists typify all would-be Chicano artists by their way of working through the new challenges brought by different settings. Throughout, personal enlistment into the Movement was tantamount to a commitment to the development of the self within a community engaged in the process of increasing historical consciousness. As Mesa-Bains points out, it is still necessary to develop analyses that can explain the Movement as it pertains to itself and the individuals affected by it, as well as to other components of American society.

The final essay "*Murales del Movimiento*: Chicano Murals and the Discourses of Art and Americanization" by Marcos Sánchez-Tranquilino examines the role of conceptual structures in the creation of a cultural movement. He emphasizes the political significance of cultural self-definition, exemplified in the use of the word "Chicano" itself, as a tool of liberation in the struggle by the Chicano community to emerge from its condition as an "internal" colony. In the same way that Chicano identity is formed through a specific combination of Indian, Spanish, and Anglo influences, the specific "Chicano" mural style is a combination of cultural influences which include American "pop" culture, art-world, Mexican, and *barrio* influences. Sánchez-Tranquilino highlights the specific role of youth participation and gang calligraphy (graffiti) in the early murals, not only in terms of the specific style that developed, but also in relation to structural factors like the use of collective painting groups and the *barrio* locations where the murals were placed.

Prior to the Chicano movement, U. S. Mexicans were defined externally through a series of derogatory stereotypes with total assimilation as the only way to break out of the situation of social marginalization. Art that integrated elements of U. S. Mexican or *barrio* culture was also denigrated as "folk" art and not considered seriously. The explosion of Chicano culture and murals as a result of the political movement, provided new recognition and value for Chicano art which weakened the old barriers. According to Sánchez-Tranquilino, this experience allowed artists to figuratively break through the wall that confined artists either to the *barrio* or to unqualified assimilation. It gave them the confidence to explore new artistic forms and a new relationship to the dominant society.

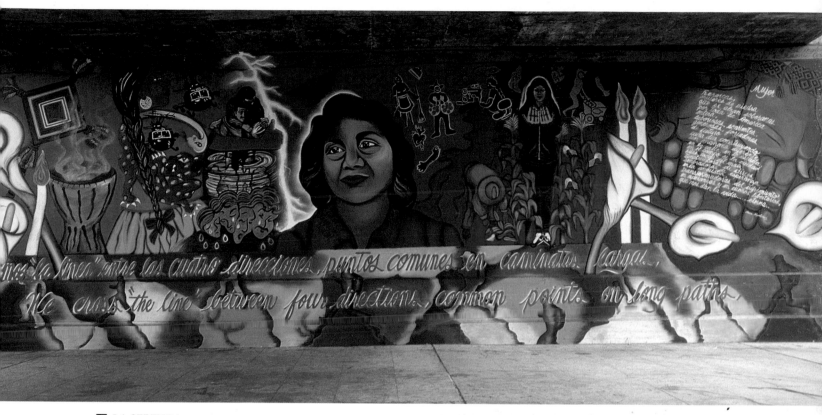

LA OFRENDA
1989
Yreina Cervántez
Toluca St. under the 1st Street Bridge, Los Angeles
16′ x 52′
A *Neighborhood Pride/Great Walls Unlimited* project.

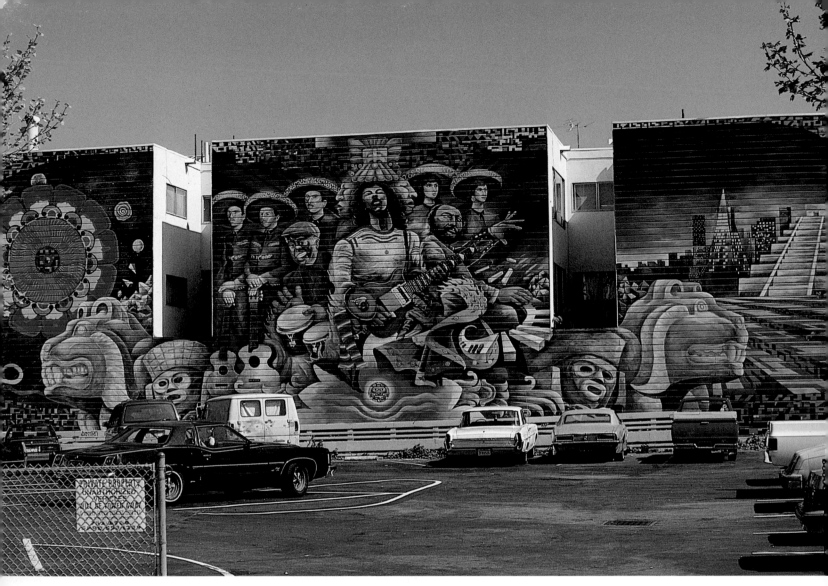

INSPIRE TO ASPIRE
1987
Mike Ríos
South Van Ness Ave. and 22nd St., Mission District, San Francisco
approx. 40' x 120'

All of the essays bring out the importance of the early years of the Chicano Movement when community activism was at it height in generating the search for identity and collective self re-definition that resulted in a flowering of Chicano culture and art. This cultural renaissance including Chicano muralism continued to develop and grow during the later 1970s as the participants grew in maturity and skill. The authors look to the future with both optimism and concern pointing out that as the century draws to a close, there is a need to reformulate Chicano identity in a way that corresponds to both positive and negative changes in status and to changed social conditions. To remain valid, an artistic movement needs to engage in continual self-criticism. It must change with the times and the needs of the community while remaining true to its own vision, its own collective self. We call to the new generation of artists, the new activists for their community, to build on the lessons of the past, while creating a future of their own.

Eva Sperling Cockcroft
Holly Barnet-Sánchez

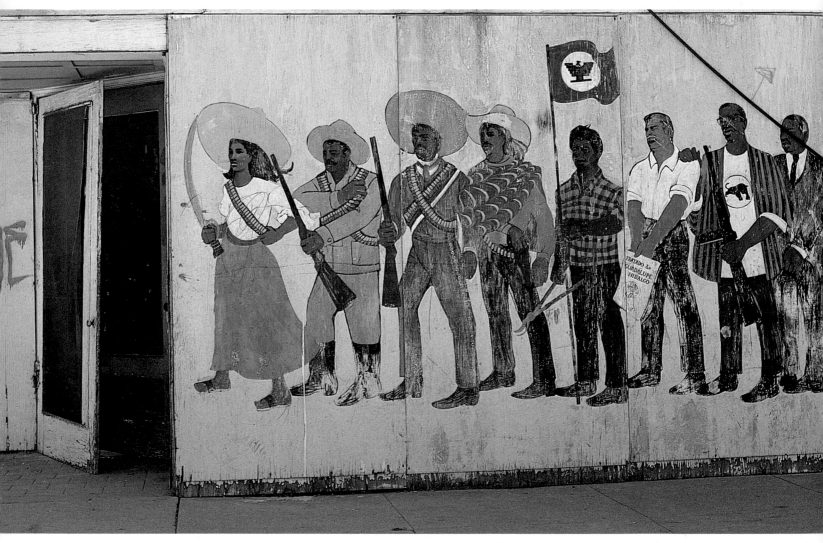

THE DEL REY MURAL
1968
Antonio Bernal
El Teatro Campesino Cultural Center, Del Rey
6' x 15'

How, Why, Where, and When It All Happened: Chicano Murals of California

Shifra M. Goldman

Muralism was the most important, widespread, cohesive, and publicized aspect of the Chicano art movement during the 1970s. As a major carrier of public communication to Mexican communities in the United States, it has been a vehicle of protest and demands addressed to the power structures for equitable solutions to problems facing those communities. It also signaled the pride, cultural values, hopes, and aspirations of Mexican community activitists, especially among the young people who formed the "troops" of the Chicano movement in the 1960s. Muralism forged an essential link between the newly emerging Chicano groupings and their Mexican heritage, encouraging a study of themes and techniques developed by the Mexican School of public art (muralism and printmaking) in the 1920s and 1930s, as well as a study of pre-Columbian painting, sculpture, and architecture which laid a basis for both the Mexican School and the Chicano art movement. In its insistence on a public voice, Chicano muralism participated in the development of a national mural movement which made its presence known, from 1967 on in the United States — and eventually in the rest of the world.

Chicano muralism[1] began as a grassroots explosion that swept numbers of artists, art students, and self-taught artists into that artistic activity. California leads the country in sheer quantity. Taking into account the murals that adorn buildings inside and out in dozens of cities

1. It should be understood that Chicano murals may be painted by teams including non-Chicano participants, or be headed by non-Chicano art directors like Bill Butler in Lil' Valley, Los Angeles, Mexican Gilberto Ramírez (San Diego and San Francisco),

large and small, there must have been more than 1,500 murals in the state during the first decade, and more were painted every year. However, a certain number of existing murals are destroyed, covered, or defaced each year and a number "vanish" due to faulty technique or because paint products have a finite life span when exposed to sun, rain, and pollution. Such murals should be subtracted from the total of existing murals, though they are available to us in reproduction and thus remain part of the history. For California, the most complete visual information available is contained within the California Chicano Mural Archive: the documented slide collection compiled by the Social and Public Art Resource Center where it is housed, with a duplicate set at the Los Angeles branch of the Smithsonian's Archive of American Art located in the Scott Gallery of the Huntington Library in San Marino, California. The archive lists 3,504 slides. Of these, 741 are of separate murals credited to 74 groups and 411 individual artists. As is indicated in the documentation, the Archive contains photographic records of murals no longer in existence. Although the Archive is comprehensive, it is not (and cannot be expected to be) exhaustive. Considering those murals not photographed over the years, those that disappeared prior to the beginning of the documentation project, and those painted since the Archive was compiled, even 1,500 seems a conservative figure.

When one considers this prodigious output of paintings that are monumental in scale, labor intensive, exhausting in terms of working conditions, and relatively costly to produce, the fact of their production in such quantity casts a clear light on the political, moral, and social imperatives that stimulated great numbers of professional and potential artists to work on walls with dedication but often with little or no remuneration. Murals are not for sale. Nor are public walls (as French-Mexican muralist Jean Charlot once pointed out) a proper surface for the naked display of self which has been a major focus in Euro-American art from 1945 on. Rather they are the logical genre for pictures envisioned as social levers. Muralists were not interested in formalist experimentation for its own sake, but only as it contributed to the community. Chicano muralists, with the high ideals and social (or revolutionary) concepts of the 1968-1975 period, were the artistic counterparts of the student and youth movements which undertook the task of "changing the world." Some artists were more than counterparts; they were participants and leaders in the political and economic struggle, considering their art (as did Mexican muralist David Alfaro Siqueiros) an integral part of their ideology.

and Puerto Rican-descent artist Manuel "Spain" Rodríguez (San Francisco). The existing determinants seem to be that a preponderance of the participants be Chicano, and/or the director be a Chicano, and the theme be related to or sympathetic with Chicano concerns.

In addition to dedication, muralists required skills: legal knowledge to obtain walls and permits; chemical knowledge about the condition of architectural walls, primers, paints, and sealers; research methods for historical murals; and sociological methods for organizing neighborhood teams and polling communities for their interests and support. They also acquired skills in fund-raising and grant writing. These were techniques not taught in schools therefore artists had to improvise and teach themselves. Some sought training in Mexico as they developed into professional muralists (such as Ray Patlán who worked with Arnold Belkin in the San Carlos Academy, and Judith Baca who attended the Taller Siqueiros in Cuernavaca). Most attacked the walls with the training they had received for easel painting and design in art schools. Some served apprenticeships with more experienced muralists until they could launch out on their own. Many started painting with no training at all but with an urgent need to express what they perceived as "truth." As a result the works were often ragged and needed better drawing, composing and painting skills. However, they exhibited what one writer on Chicano theatre has defined as *rasquachismo*: the virtue of opposing the refined finished product of bourgeois art with "unpolished vitality." [2]

Chicano murals, born in the heyday of "modernism" — with its emphasis on formal elegance, abstraction to the point of minimalism, and an elite appeal — insisted on representationalism if not actually social realism of the type brought to its apotheosis in Mexican murals. The murals insisted on "messages," on narrative, on history painting, in a period which derided these attributes in art. Chicano art students resisted their professors in art school, and ignored their lessons after they graduated. They drew together for mutual support, encouragement, and strength in their oppositional stance. From this communalism came *chicanidad* and *hermandad* (Chicano consciousness and brother/sisterhood) and the organization of mural groups, art galleries, centers, and alternative publications.

Considering the above, it is pertinent to the history of modern art to develop the chronology of public muralism in the 1970s and 1980s; to set it within its historical and art historical context; to indicate the themes and the significance of the iconography that preoccupied the artists; to explore the artistic structures established by Chicano artists to organize and provide support for muralism; to examine the changing nature of political activity and social consciousness as these changes affected mural content and patronage; and, finally, to indicate the present status of the mural movement in California.

2. Yvonne Yarbro-Bejarano, "The Female Subject in Chicano Theatre: Sexuality, 'Race' and Class," *Theatre Journal*, 38.4 (1986).

■ BIRTH OF THE CHICANO MURAL MOVEMENT: 1968 - 1970.

Themes and Their Times

In representational art the theme (or subject), as well as the iconography, are the means by which communication is established. As we have seen, communication — not just aesthetic pleasure, though this was certainly not ruled out — was primary for Chicano muralists. In order to create visual forms that could convey meanings not previously existent, images and iconography were both borrowed and invented. Content is also conveyed through forms themselves: the ways in which color, line, shape, space, value, scale, placement, and framing are used; or the degree to which objects are naturally rendered or expressively distorted. In the continual struggle between idea and rendering, between tradition and experiment, between skill and apprenticeship, the themes, meanings and formal language of Chicano muralism were developed. A constant dialogue took place between the power struggle of the movement against the dominant society to achieve its needs and aspirations, and the unfolding of the artists' abilities to translate, comment on and contribute to that struggle. In the course of that dialogue, motifs were developed from the concepts of the movement itself to which the artists gave visual form. We can do no more in the confines of this chapter than to give some examples of this dialogue, and indicate the kinds of themes that were prevalent in various time periods.

As far as can be determined, the earliest Chicano murals in California are the two 1968 panels painted in Del Rey by Antonio Bernal on the United Farm Workers' Teatro Campesino Center. They merit special attention not only for their early date, but for the example they present of iconography later prevalent in the politicized murals of the 1970s. In one, pre-Columbian[3] rulers line up Bonampak-like horizontally, headed by a woman; in the other, a sequence of admired leaders from the Mexican Revolution to the 1960s are led by "La Adelita", a revolutionary woman soldier. She is followed by Francisco "Pancho" Villa, Emiliano Zapata, Joaquin Murieta (a Mexican or Chilean outlaw-hero on this side of the border), Cesar Chávez of the United Farm Workers, Reies López Tijerina of the New Mexico land grant movement, a Black Panther, and Martin Luther King, Jr.[4] The mural thus encompasses the past events and personalities that most influenced the Chicano movement: the indigenous cultures of pre-

3. Bonampak is the site of an ancient Maya city now located in Chiapas, Mexico. It was abandoned prior to 900 A.D. and contains a series of murals.
4. The Black Panther figure has been identified by Luis Valdez of the Teatro Campesino as Malcolm X (telephone conversation with author, November 10, 1986). However, despite the eyeglasses, the figure wears a striped dashiki, has a panther on his shirt, and carries a machine gun – symbols and instruments not associated with Malcolm X or the Black Muslims. The Black Panthers were organized in California in 1966 and made their base in Oakland. It is possible that the artist, a Chicano welfare worker from

Columbian Mexico and the Revolution; and (from the 1960s) the Black civil rights movement and leaders of the Mexican/Chicano Movement in the persons of Chávez and López Tijerina.

The years from 1968 to 1970, when the mural movement began to pick up momentum, were filled with significant events. 1968 proved to be a year of international student protest; from Tokyo to Paris, from Mexico City to many cities in the United States. In East Los Angeles, the famous high school "blowouts" had repercussions among Chicano students across the country. By May 1969, 10,000 people attended the "Fiesta de los Barrios" organized by the "blowout" committee at Lincoln High School. This was the first gigantic Chicano cultural event of California and it inspired Francisco X. Camplis of San Francisco's Casa Hispana de Bellas Artes to assemble "Arte de los Barrios," a traveling exhibition of Latin American and Chicano art.[5] Eventually the cooperative group Arte 6 was formed, and it became, in its turn, the (largely Chicano) Galería de la Raza of San Francisco.

At the same time that the Fiesta was being planned in Los Angeles, a seminal group of San Francisco artists organized the Mexican American Liberation Art Front (MALAF) which, in March 1969, sponsored the "New Symbols for la Nueva Raza" art exhibit. MALAF was a militant group formed "for the purpose of organizing Chicano artists who are interested in integrating art into the Chicano social revolution sweeping the country."[6] The four artists who formed MALAF were Manuel Hernández-Trujillo, Malaquías Montoya, Esteban Villa, and René Yañez — all key figures in the production and promotion of mural painting. During 1971 Yañez, as co-director of the Galería de la Raza, was instrumental in promoting a mural program in the Mission district of San Francisco. Villa, and José Montoya (who also participated in MALAF), established the Rebel Chicano Art Front (later known as the Royal Chicano Air Force, based on the initials RCAF) along with their students from Sacramento State College. This occurred after teaching positions had opened up for the two artists in 1969 and 1970 respectively. Between 1969 and 1970, Villa and his students painted the mural *Emergence of the Chicano Social Struggle in a Bicultural Society* on the walls of the Washington Neighborhood Center.[7] Employing five gigantic expressive figures, the mural delivers a message about liberation through militant self-defense and self-enlightenment. At the same time, Malaquías Montoya and Hernández-Trujillo began working on murals in the East Oakland Development Center. The former

Fresno who used the professional name Forest Hopping, intended the figure to be a composite of Malcolm X (who was assassinated before the formation of the Black Panthers) and the Panthers. Both groups offered ideological alternatives to those of King.
5. Francisco X. Camplis, interview with author, 29 September 1978.
6. "Nueva Raza Art Show in Oakland," *San Francisco Chronicle,* 21 March 1969.
7. Alan W. Barnett erroneously dates this mural to 1968. See *Community Murals* (Cranbury, NJ: Associated University Presses, Inc., 1984), p. 67 and *passim*.

concerned armed struggle, education, and self-knowledge; the latter symbolically projected the idea, through pre-Columbian images of the jaguar (night) and sunlight, that maize plants (i.e. human beings) can grow in spite of vultures and oppression.

In 1969-70, the González brothers of East Los Angeles, working with a team, painted the mural, *The Birth of Our Art*. It was to be affixed to the facade of the new Goez Imports and Fine Arts Gallery when it opened. The mural represented the *mestizaje* (mixing) of the Spanish and Indian peoples, the Mexican ancestors of those who were to produce Chicano art. Goez Gallery was a for-profit space from the time of its inception. The gallery offered services such as "art sales of traditional, modern and pre-Columbian paintings and sculptures, restoration of the fine arts, imports from Mexico and Spain, custom designed furniture, frames, advertising design, [and the] designing and construction of murals, monuments, shrines, and fountains."[8] Subsequently, Goez became part of the community mural program and obtained funding to make wall paintings. Artists from its ranks were to play an important role in the East Los Angeles mural community. Such was the case for David Botello, who (with Wayne Alaniz Healy) became one-half of Los Dos Streetscapers; and Charles "Gato" Félix, who, by initiating and heading the mural program at Estrada Courts, made his commitment to enhancing the living space of a working class community.

In 1970, Judith Baca expanded the definition of her teaching job with the Department of Recreation and Parks in order to organize gang members of East Los Angeles into mural teams. Starting with twenty people from four different neighborhoods, Baca painted murals during the summer, including *Mi abuelita* (My Little Grandmother), in a three-sided bandshell of Hollenbeck Park. After this experience, she began to understand that murals and the visual symbols they employed could "break down the divisions among...people, give them information and change their environment."[9]

With these several examples, we can see that the mural movement resulted from an almost "spontaneous combustion," influenced directly or indirectly by the strikes and boycotts of the United Farm Workers Union, the militant Chicano Movement, and the spiritual and cultural concerns of writers and artists who were active in the movement. Teatro Campesino was one of the earliest cultural manifestations of the new Chicano Movement. Outward rippling effects from the Union and the Theatre spread to other expressive forms including literature,

8. Goez Gallery brochure, c. 1971.
9. Judith Baca, "Our People are the Internal Exiles," an interview by Diane Neumaier in *Cultures in Contention*, ed. Douglas Kahn and Diane Neumaier (Seattle: The Real Comet Press, 1985), p. 67.

visual arts, music, and dance to produce what can rightly be called a "cultural explosion." Between 1971 and 1975, early experiments led to a virtual flood of murals, particularly in Los Angeles which could be called the mural capital of the Southwest, if not the nation. Parallel movements blossomed in the San Francisco Bay cities and in San Diego. From these areas it spread, by the end of the decade, to many other cities in the state. We can record (in arbitrary order) Santa Ana, Orange, Tustin, Anaheim, Riverside, Santa Barbara, Santa Cruz, San Jose, Redwood City, Gilroy, Watsonville, Palo Alto, Sebastopol, Santa Rosa, Windsor, Bakersfield, Delano, Visalia, Hanford, Sanger, Fresno, Malaga, Highway City, Madera, Merced, Davis, and Vacaville. The San Francisco Bay area includes Daly City, Berkeley, Oakland, Emeryville, Hayward, and Union City. Smaller cities surrounding Los Angeles and San Diego were also invaded by murals.

■ MURAL SUBJECTS

Early Themes

Themes for murals were suggested to artists by contemporary events and the new philosophy of the Chicano movement. The following categories give some idea of their range:

Religion: Pre-Columbian (especially Olmec, Toltec, Aztec, and Maya) deities such as Quetzalcoatl (the feathered serpent), the rain god Tlaloc; the Aztec "Calendar Stone;" the Chac Mool and other pre-Columbian signs and symbols; West Mexican funerary dogs; pre-Columbian rituals; pyramids and temples; Christian churches; Christian signs and symbols; altars; the Virgin of Guadalupe and/or her roses; the crucified Christ and/or crosses, bleeding or flaming hearts, thorns; bishops and parish priests (sometimes satirically).

Indigenous motifs: The tripartite head (Indian Spaniard/Mexican or Chicano), contemporary Native Americans, Pre-Columbian warriors and families.

Historical events: Pre-Columbian rulers (like the chronicle of Mixtec ruler 8-Deer); the Spanish conquistadores; colonial Mexican culture; the Mexican Revolution; Native American and Chicano history.

Modern portraits: Cesar Chávez, Reies López Tijerina, Emiliano Zapata, "Pancho" Villa, "La Adelita," Benito Juárez, Father Miguel Hidalgo, José Maria Morelos, John F. Kennedy, Ernesto "Ché" Guevara, Rubén Salazar, Luis Valdez, Martin Luther King, Jr., Pablo Picasso, and David Alfaro Siqueiros.

Political and social: On local issues: education, police brutality, drug abuse, prison conditions; gang warfare and gang pride reflected in memorials to deceased members; images of "home boys" and "home girls;" health care, and portraits of community people. On national issues: the strikes,

marches, and boycotts of the United Farm Workers of America (UFW); working conditions of farm workers (stoop labor, migrant workers); grapes and wine themes reflecting the boycotts; caricatures of "Uncle Sam;" and the paramilitary self-defense Chicano group called the Brown Berets. On international issues: images of the U.S. military; guerrillas in the Third World; the war in Southeast Asia; and celebrations of Latin American and Caribbean culture.

Non-religious symbols: *Con Safos* or "C/S" (roughly translated as "the same to you") graffiti, scales of justice, tomb stones, hearts, feathers, chains and broken chains, mirrors, the Mexican eagle, the UFW black eagle, and the U.S. eagle (all with different meanings). The UFW flag; the U.S. flag; the Pan-African, Puerto Rican and Cuban flags; *calaveras* (animated skeletons à la Posada); atomic symbols; suns and sun symbols; fire; extended hands, clasped hands and clenched fists; moons; bags of gold; and dollars.

Landscapes, flora and fauna: Volcanos, snow-capped mountains, deserts; cactus plants (nopal or prickly pear, and maguey), palm trees, corn plants and ears; horses and other animals.

Decorative motifs: Supergraphics and other geometric abstractions; pre-Columbian geometric forms used decoratively; organic abstractions, motifs from Mexican folk art.

Family: Mother and child, mother and children, whole families, grandmothers. Families in many social situations.

Urban culture: Pachucos/as, *cholos/as*, lowrider cars, graffiti, cityscapes, skyscrapers, *barrio* homes, freeways, trains, etc.

Legendary or mythical figures: *La Llorona* (the Weeping Woman), Superman, Popocateptl and Ixtaccihuatl (volcanos in Mexico: Indian warrior and the sleeping woman, or the warrior carrying the woman).

Texts: Words and phrases used in the body of (or to one side of) a mural: manifestos, titles, explanations, names of personalities, documents (historical and contemporary), memorials, poetry, and slogans like "Viva la Raza," or "End Barrio Warfare."

Later Themes
Looking ahead to the post-1975 period, we find that many of the above themes continue to appear. New subjects emerge. Most notable is the tendency to include and comment on international themes — particularly, in recent years, on unity between peoples of color. Increasingly, solidarity with the oppressed peoples of Central America (with an emphasis on Nicaragua, El Salvador, and Guatemala) are expressed in murals. The most extensive project of this nature was San Francisco's PLACA Project. The "Balmy Alley Mural Environment" included

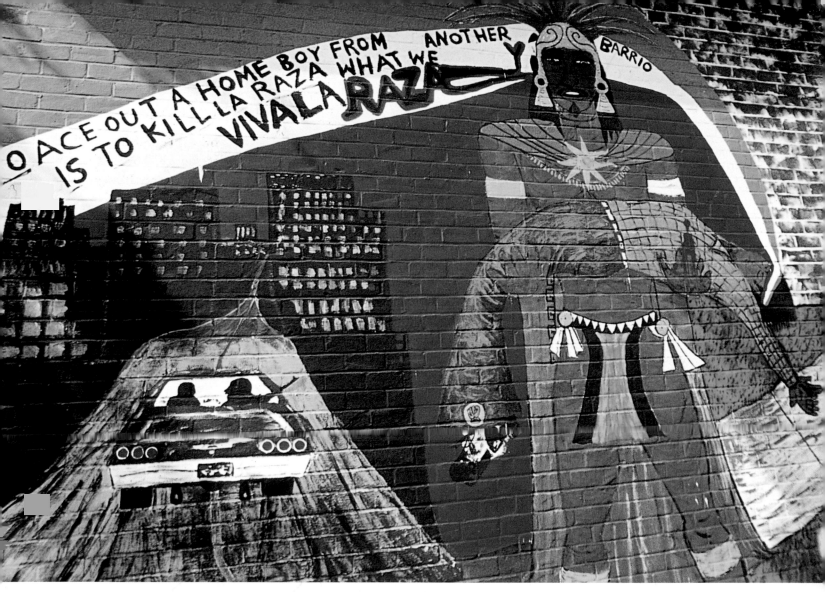

UNTITLED (HOMEBOY), detail
1974
Manuel Cruz
Ramona Gardens Housing Project, East Los Angeles,
total mural approx. 16' x 20'

THE HISTORY OF L.A., A MEXICAN PERSPECTIVE
1981 - 83
Barbara Carrasco
portable, unmounted 16' x 80'

more than twenty-five murals on Central America, which were painted by a multi-ethnic group of artists in 1984.[10] Murals were also commissioned during national and local celebrations such as the U.S. Bicentennial in 1976, the Los Angeles Bicentennial in 1981, and the 1984 Olympic Games, held in Los Angeles. On the occasion of the Los Angeles Bicentennial, most of the murals were laudatory. One that was critical and undertook to document the history of L.A. minorities, was Barbara Carrasco's portable painting *The History of Los Angeles: A Mexican Perspective*. As a result, it was rejected, and has not been installed as of this writing.[11] The Olympic murals, painted by a multiethnic group including Judith Baca, Willie Herrón, and Frank Romero, were eclectic in style and theme. Baca, for example, undertook to celebrate (as a continuation of her historic

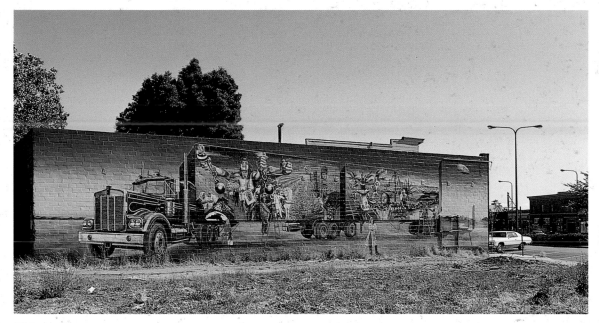

VIVA LA RAZA
1977
Daniel Galvez with Osha Neuman, Brian Thiele and S. Barrett
1512 Adeline St., San Francisco
15' x 70'

10. See *Community Murals Magazine* (Fall 1984): 10-13.
11. See *ChismeArte*, no. 9 (September 1983): 20-21.

Great Wall mural project) the sports successes of women of color. Unfortunately, the locations chosen for the ten artists were the walls of downtown freeways, a hazard both to the painters and the motorists who wished to see the work.[12]

Portraits included an expanded cast in the post-1975 period: Diego Rivera, Frida Kahlo, and José Clemente Orozco were added to the roster of Mexican artists; Los Angeles leader Bert Corona, movie star Anthony Quinn (among portraits of many actors and actresses), UFW leader Dolores Huerta, 1950s labor organizer Luisa Moreno, murdered Chilean folk singer Victor Jara, and Northern California songwriters Daniel Valdez and Malvina Reynolds now appeared. Some unflattering portrayals of Ronald Reagan also showed up, as did portraits of Northern California arts people, including muralist Ray Patlán.

Themes from urban culture began to include street and community people of all types — particularly in the photorealist murals of Los Angeles' John Valadez, and Oakland's Daniel Galvez. Slum lords and arson, food contamination, and junk food have been added to the roster of social evils. Finally, a group of ten multiethnic muralists in San Francisco, undertook a mural sculpture, *An Injury to One is an Injury to All*. Sponsored by the International Longshoremen's and Warehousemen's Union (ILWU) and the Mayor of San Francisco, the mural commemorated the 50th anniversary of the 1934 General Strike. Ray Patlán took a leading role in the production of this mural, as he did in the PLACA endeavor.

■ WHO DID WHAT WHERE:
Art and Mural Groups

> *Mural groups have been characterized by the "team" approach, i.e. an art director working with a group of artists and/or community residents. Mural artists have also solicited community input as a guide to relevance of a given theme and its articulation. The notion of an artistic team collaborating on a public mural can be found in the early writings of Siqueiros, however the inclusion of (often untrained) community participants as painters appears to be unique to the U.S. street mural movement of the 1970s. Subscribing to a collectivist philosophy at the point of production counterparts a similar philosophy in regard to dissemination. Briefly summarized {most} public artists work as a team and address their work to a community which, hopefully, will understand and subscribe to its message. This stance negates the individualism and elitism common to mainstream fine arts.[13]*

12. Suzanne Muchnic, "Art From the Fast Lane," *Los Angeles Times*, 15 April 1984, *Festival Magazine*, pp. 76-79; and "Los Angeles Freeway Murals Honor the 23rd Olympiad," *Images and Issues*, 5, no. 1 (July/August 1984): 14-19+.
13. Shifra M. Goldman and Tomás Ybarra-Frausto, *Arte Chicano: A Comprehensive Annotated Bibliography of Chicano Art, 1965-1981* (Berkeley: Chicano Studies Library Publications Unit, University of California, Berkeley, 1985), p. 53.

34

The notion of a "team" or collective, which characterized mural production of the early 1970s, does not preclude individual muralists making works of great power and relevancy. However, Chicano artists in all disciplines tended to group together for mutual support and, in the face of institutional neglect or hostility, for commissions and funding. We will briefly trace the interaction between groups and individual artists and highlight some examples.

Northern California

Sacramento. Like many Chicano arts organizations in California, the Royal Chicano Air Force (1969) and the umbrella group known as the Centro de Artistas Chicanos (1970), which form the structural base for muralists in Sacramento (applications for funding, locating walls, signing contracts, and other logistical, not to mention spiritual support), maintain profiles on a number of fronts. With roots in the farm workers organizing drives and boycotts, as well as MALAF (the Mexican American Liberation Art Front of 1969), the thrust of the Centro and the RCAF has been economic, political, cultural, and social. In addition to murals and silkscreen programs, the Sacramento group has run classes for children, teenagers, and seniors; regularly celebrates Mexican national and folk holidays; participates in Native American rituals; has run a free breakfast program for children, and maintains a bookstore and a gallery. Poetry (José Montoya is as well known for his poetry as his art), theatre, dance, music, and sports round out the community curriculum.

Villa's 1969 mural (mentioned earlier) provided the inspiration for a continuing mural program, some of it — supported until the program was cancelled — by federal funding from CETA, the Comprehensive Employment and Training Act. According to a *Los Angeles Times* article of July 22, 1979, RCAF artists painted fifteen murals in Sacramento, including a major work depicting various aspects of Chicano culture at the city's Southside Park.[14] The Southside Park murals of 1977 are by Juanishi Orosco, Esteban Villa, José Montoya, Juan Cervantes, Lorraine García, Sam Ríos and Stan Padilla. Centro artists also painted murals in Seattle (Washington), Burley (Idaho), Tempe (Arizona), Chicano Park in San Diego, and Los Angeles. Armando Cid decorated La Raza Bookstore with a mural in 1973, and when Sacramento Park changed its name to Zapata Park in 1975 due to the efforts of community activists and Centro artists, Cid did a mosaic mural there. In 1979, Louis "The Foot" González and Juan Cervantes painted a large mural, *Aeronaves de Aztlán*, on a wall of their cooperative garage. It depicted a

14. Charles Hillinger, "The Royal Chicano Air Force: Activists in Sacramento Use Humor to Instill Pride," *Los Angeles Times*, 22 July 1979, section I, p. 3+.

proud Chicano mechanic holding a wrench and surrounded by billowing clouds, a blazing sun, and an eagle. In 1980, Centro artists Esteban Villa, Stan Padilla and Juanishi Orosco designed a four-story, 65 foot symbolic mural for the downtown city parking lot facing the Street Mall. The exuberance and collectivist principles of the RCAF as well as their dedication to the educative and community uplift aspects of public art were not limited to the Sacramento area. Like MALAF, the RCAF was an important influence on Chicano artists throughout the state, many of whom did stints with the Sacramento group or visited them to learn about their methods and philosophy. In fact, networking was established early, not only within California but throughout the Southwest. Artists travelled to the various "Canto al Pueblo" national events which, from 1977 on, brought together Chicano artists of all disciplines, and at which visual artists painted murals. The group which unified California was the State Coalition of Artistas, founded in 1973 and known from 1975 on as CAP, the Concilio de Arte Popular. Among its activities, CAP published the magazine *ChismeArte*.

San Francisco Bay Area. When the Galería de la Raza of San Francisco printed its first mural map — the "Mission Community Mural Tour Guide" — it listed ten mural sites: the 24th Street Mini-Park (1974-5); the Mission Coalition Organization (Neighborhood Legal Aid, 1972); Horizons Unlimited (1971); the Mission Rebels mural (1972); Jamestown Community Center (1972); the Bank of America (1974); the Mission Model cities Neighborhood Center (1974); Paco's Tacos (1974); and the Balmy Alley murals (1973). In the overwhelmingly Latino and Asian Mission District are early works by some of the key Raza (Chicano and Latino) muralists of the city: Michael Ríos, Anthony Machado, Richard Móntez, Domingo Rivera, Jerry Concha, the Mujeres Muralistas, Luis Cortazar, Jesus "Chuy" Campusano, Manuel "Spain" Rodríguez, Rubén Guzman and others, directed or assisted by non-Raza artists. In 1971, the Galería de la Raza was a germinal force for Bay area muralism. Itself an expression of increasing consolidation within the Chicano/Raza art community (MALAF, the Casa Hispana de Bellas Artes, Artes 6, and the Artistas Latino Americanos), the Galería was established in 1970 under the directorship of Nicaraguan Rolando Castellón. It was homeless in mid-1971, at which time René Yañez applied for mural funding which permitted the production of some of the wall paintings listed above. The Galería finally settled at its present 24th St. & Bryant location where it functions actively to this day.

In 1975, the Galería added an innovation to community murals when it "appropriated" a Foster and Kleiser billboard on the side of its building to serve as an "announcement mural." Removed by the commercial company in December 1976, the billboard was replaced due to public pressure, and it changes regularly as artists paint new images and messages. As

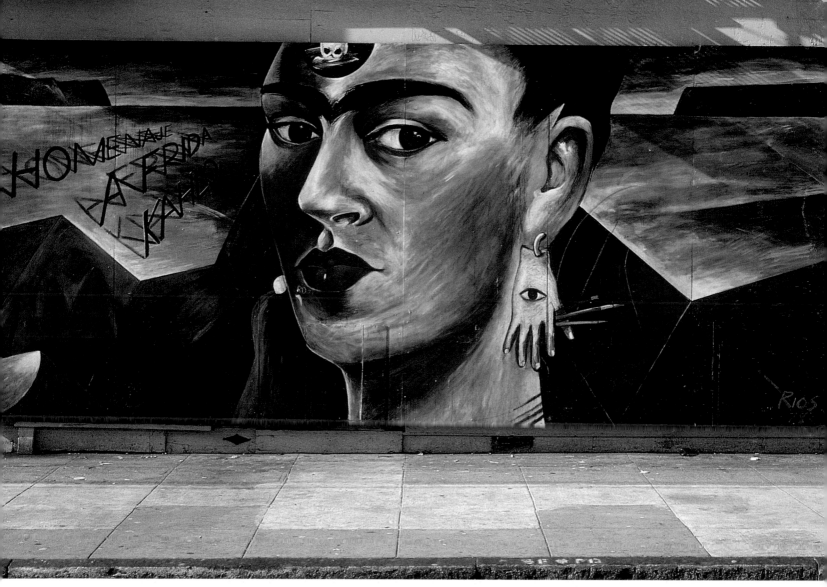

FRIDA, BILLBOARD
1978
Mike Ríos
Galería de la Raza, Mission District, San Francisco
8' x 20'

Yañez pointed out, "Times, needs, issues shift" and a frequent changing of images and ideas makes the billboard into a living and constant part of the community. The Galería withdrew from mural programming in 1976 when funding issues and the changing character of public murals (for Yañez, their increasing vagueness and loss of concern with contemporary issues) made such a move desirable.[15] San Francisco was not the only city that saw a decrease in mural relevancy and an increase in decorative murals by the end of 1975. Such a phenomenon has been observed nationally. It was accompanied by growing difficulties with national arts funding that had supported community muralism and that had been part of government policy in the early 1970's to "cool out" militancy and protests in inner cities across the nation.

Despite the Galería's withdrawal, many significant murals continued to be painted in San Francisco and other Bay area cities during the next ten years. Portable murals were introduced. Most notable were the eight "People's Murals" commissioned by the San Francisco Museum of Modern Art. Painted by fourteen multiethnic artists, including Graciela Carrillo, Anthony Machado, Robert Mendoza, Irene Pérez, and Michael Ríos, many of the works were powerful and militant statements. They contrasted with many of the Bicentennial art productions found elsewhere that were bland, "trendy" or decorative. Six years later, in May 1982, the Galería commissioned nineteen multi-ethnic artists to create portable murals in its gallery space as part of a month-long event called "In Progress", which encouraged the public to watch the artists at work. Included were Raza artists Tony Chávez, Juan Fuentes, Daniel Galvez, Rayvan Gonzales, Yolanda López, Raul Martínez, Emmanuel Montoya, Ray Patlán, Michael Ríos, Patricia Rodríguez, "Spain" Rodríguez, Herbert Siguenza, Xavier Viramontes, and Rene Yañez.

Galvez, Montoya, and Patlán are three artists who started to be known in the Bay area after 1975. Patlán came to the Bay area from Chicago where he had produced a notable body of murals during the early 1970s. By 1977, Patlán and Patricia Rodríguez, working with University of California Chicano Studies students, had painted two murals in Berkeley. Between 1977 and 1979, Patlán and Galvez were active with Commonarts. Galvez, a younger artist working in a photorealist style, collaborated with Osha Neumann, O'Brian Thiele and Stephanie Barrett on his design for *Viva La Raza* (1977) in Berkeley: it featured the image of a huge truck dedicated to the farm workers and the Mexican muralists. Patlán, Neumann, Thiele, and ceramist Anna de Leon achieved a major artistic and social breakthrough with their three-dimensional mural on the facade of Berkeley's La Peña Cultural Center. *Song of Unity* (1978) was dedicated to the popular music of North and South America and to slain Chilean songwriter

15. Barnett, p. 243.

Victor Jara. In 1979, the team of Patlán, Neumann, and Thiele was commissioned by the East Bay Skills Center in Berkeley to paint a work skills-related mural. Both Patlán and Galvez work continuously in their very different realist styles, regrouping their artistic structures as new possibilities and opportunities arise.

Women Muralists

Three Chicanas — Patricia Rodríguez, Irene Pérez, and Graciela Carrillo — and a Venezuelan artist, Consuelo Méndez, were the original Bay Area team comprising the Mujeres Muralistas. All but Méndez had done their first murals in Balmy Alley the previous year. Their friendship

PARA EL MERCADO, detail
1974
Las Mujeres Muralistas (Patricia Rodríguez, Graciela Carillo, Consuelo Méndez, Irene Pérez)
South Van Ness Ave. and 24th St., Mission District, San Francisco
total mural approx. 10' x 50'

was cemented when they received their first commission for the Mission Model Cities Neighborhood Center office parking lot in 1974. Painting *Latinoamérica*, (originally titled *Panamérica*) which was intended as a celebration of the Latin cultures in the Mission district, each artist took responsibility for her own subject matter. Venezuela, Bolivia, Mexico, and Peru were featured with images of the plants, animals, traditional dances, costumes to be found in each stressing the major role of the family in each country. As the four artists developed and painted the mural, each modified her sections as she worked to create a unified whole. No color sketch ever existed; balancing was done in advance with line drawings and at the mural site itself as the painting progressed. Each artist worked individually, secure in her confidence that together they could achieve a good result. The second mural *Para el Mercado* (For the Market) was painted in two halves by Carrillo and Méndez for Paco's Tacos stand and dealt with foods for the Latin American marketplace. Brilliant color and flat drawing were characteristics that the four shared (all had previously done silkscreen posters as well as paintings). The Mujeres' murals were challenged in the community for being apolitical; however they had decided that the men's murals of the time had too much "blood and guts" and that they wanted a more positive image of their culture.[16] With the help of a number of other women — Ester Hernández, Miriam Olivo, Ruth Rodríguez, and non-Latina Susan Cervantes, the Mujeres painted murals for two years and then disbanded and worked on as individuals.

Women have been very active in Bay area muralism. As with Judith Baca, who played a pioneering role in Southern California in an artistic genre where women's participation was discouraged by convention and their menfolk, the Mujeres were both germinal and inspirational for women artists of Northern California. Many like Las Mujeres Muralistas del Valle of Fresno took courage from their example. Fifteen Fresno women including Helen González, Cecelia Risco, Sylvia Figueroa, Theresa Vásquez, and Lupe González, started work in 1977 on an outdoor 60 x 80 foot mural for Parlier labor camp which was funded by La Brocha del Valle. Vandalized a year later with the words "The white race is the right race," it was restored and housed indoors.

Women students from San Diego calling themselves the Mujeres Muralistas were organized by Yolanda López in 1977 to contribute a pillar mural on Indian women during the Muralthon which revived painting at San Diego's Chicano Park. (The same park has an early (c.1973) women's mural by the Grupo de Santa Ana, also from Southern California, on the growth of corn, the human fetus, and la Raza). A 1975 mural picturing women of Latin America and two joyous nudes with flutes was painted at Chicano Park by RCAF women Rosalinda Palacios,

16. Irene Pérez, interview with author, 29 May 1982.

40

Antonia Mendoza, and Celia Rodríguez who had returned inspired from the first International Women's Conference of 1975 in Mexico City. They also painted a tribute to southern Black prisoner, Joan Little, who had killed a sexually abusive guard.

In the 1980s, Juana Alicia has emerged as a strong muralist with several works in the Mission District including *Las Lechugeras* (The Lettuce Pickers, 1983), and a 1985 mural on the San Francisco Mime Troup's headquarters.

Mid California

Fresno. By no means was all mural production spontaneously begun, as seems the case in the 1968-1970 period. Further research may reveal connective links even in this early period, not excluding the influence of teachers with remnants of New Deal ideas. In the decade of the seventies, however, news travelled outward from mural centers like San Francisco and Los Angeles through personal and organizational contacts. Ernesto Palomino, "elder statesman" of La Brocha del Valle of Fresno, received his art education in San Francisco from 1956-1965 and began teaching at California State University, Fresno, in 1970. Politicized in the intervening years by his search for cultural identity and his contact with the Chicano movement in Colorado where he went to live, he was active with the Colorado Migrant Council and was a friend of poet Abelardo Delgado. He knew of the Los Angeles High School walkouts and the strike at San Francisco State University when he painted his first mural in Fresno in 1971: a flatbed truck seating farmworkers on their way to the fields, surmounted by a nude Chicana "Virgin" and an eagle with radiating sun rays taken from the Sunkist Raisin logo. Both were flanked by a pre-Columbian warrior, a skeletal farm worker holding grapes, and a great serpent. Palomino was familiar with Antonio Bernal's Del Rey mural, and with Esteban Villa's *calaveras* which the RCAF adapted from 19th century Mexican engraver José Guadalupe Posada.

La Brocha del Valle was begun by Palomino and other Fresnoites about 1974 and officially incorporated as a non-profit group in April 1976 by Palomino, Fernando Hernández, Salvador García, and Francisco Barrio. It then launched a program of exhibits and mural production. La Brocha was also affiliated with the Concilio de Arte Popular. From 1978 on, murals were painted in summer programs with young people under the direction of the founders of Brocha, as well as by Cecelia Aranaydo and Juan Turner. From 1976 to 1981, Los Angeles muralist and organizer Gilbert "Magu" Sánchez Lujan taught at Fresno City College and became active in Brocha. Between 1979-1982, John Sierra completed a 6600 square foot mural, *Planting of Cultures*, on the California State Building in Fresno.[17]

17. Lloyd C. Carter, "Valley Life Mural in Fresno Finally Complete," *Los Angeles Times,* 1 August 1982, Metro section, p. 1.

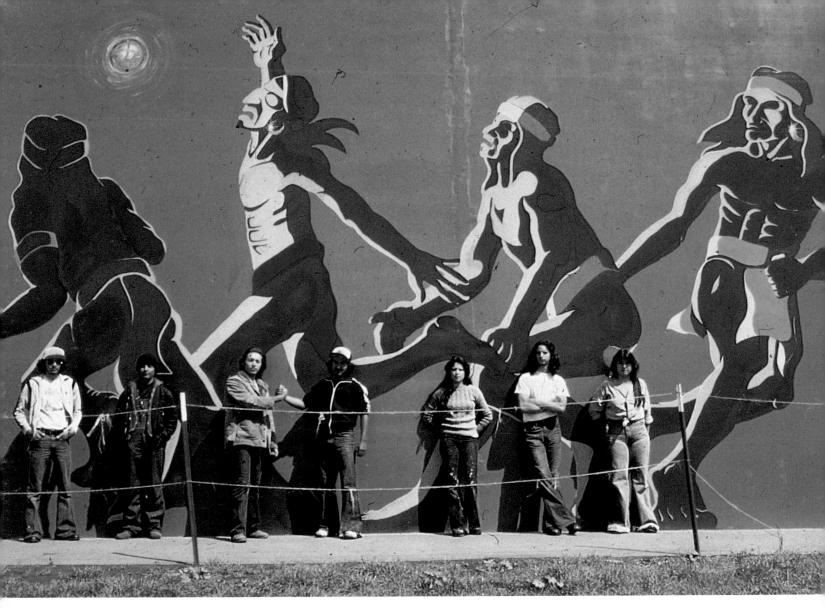

BALLPLAYERS (TLACHIT)
1978
Tortuga Patrol (Ray Olmo and Ralph de Oliveira)
Chicano Park, Gilroy
8' x 50'

San Jose/Santa Cruz. Santa Cruz, San Jose, Watsonville, and Gilroy are so close to each other that interchange occurred between them, and with Fresno. In the early 1970s, painter Jaime Valadez was associated with the Centro Cultural de la Gente de San Jose, and in 1978 he conducted the *Tierra Nuestra* and the *Flor de la Comunidad* mural projects. According to Alan Barnett who teaches in San Jose, the first mural was probably a frieze upon a legal-aid office painted in 1972 by Malaquías Montoya. In 1974, Rogelio Duarte of Los Angeles, apparently working alone, painted three murals at San Jose State and on a local market.[18]

In 1972, painter Eduardo Carrillo came to teach at the University of California, Santa Cruz. His first mural had been a collective one in 1970 at the Chicano Studies Research Center of the University of California, Los Angeles, painted with Ramses Noriega, Sergio Hernández and Saul Solache. A respected easel painter since the early 1960s, Carrillo had been arrested in Los Angeles during the 1970 Anti-Vietnam War Moratorium, and had taught at Sacramento State College from 1970-72, during the early years of the RCAF. In 1976, he donated a 2500 square foot mural to the Palomar Arcade in Santa Cruz called *Birth, Death and Resurrection* which was destroyed in 1978; Carrillo was never successful in having it restored. In 1979, he engaged a Mexican independence theme in a commissioned tile mural located at the Placita del Dolores of Los Angeles' Olvera Street.

Watsonville/Gilroy. In its Summer 1978 issue, *ChismeArte* magazine illustrated a new mural by the Tortuga Patrol from Watsonville which was painted by students in the Gilroy recreation Center, and directed by Ray Romo and Ralph D'Oliveira. Humor, and a major input from José Guadalupe Posada, are evident in this work. The same year, the Tecolote Corps painted a large outdoor mural for the Gilroy Unified School District.[19]

Southern California

Santa Barbara. More than any other individual, Manuel Unzueta has provided the inspiration and leadership for muralism in Santa Barbara. His activities have been centered at La Casa de la Raza, with the enthusiastic support of its director of cultural arts, Armando Vallejo. For a number of years Unzueta also taught mural classes at the University of California, Santa Barbara. "When I first accepted the challenge to paint murals at La Casa de la Raza in 1971," says Unzueta, "I engulfed myself in one of the greatest experiences of my life." Commenting on his murals inside

18. Barnett, pp. 157-158.
19. Reproduced in the 1985 Social and Public Art Resource Center calendar.

Casa, he continues: "The mural *To the Mexican Song*, (1973) shows my concern and pride towards my Mexican past. *A Book's Memory*, (1972) is a very personal expression on my own views about education and knowledge. *The New Spirit*, (1973) is an intention to portray the reality of the Chicano movement. *{Allegory to} Brotherhood*, (1973) shows my sincere attitudes to relate to all people regardless of color of skin or cultural background."[20] In 1979, Casa approached the city "for moral and financial support to paint murals over the graffitied walls of Ortega Park" (unofficially known as Rubén Salazar Park in place of the "old California Spanish family" after which it is named). Under the direction of Vallejo, nineteen murals were produced by six local artists guiding community volunteers. The themes ranged from the Aztec era to cosmic unity. [21]

Los Angeles County and City. In 1969, about 2000 people organized by the Brown Berets demonstrated in East Los Angeles to protest the Vietnam War and the high percentage of Chicano military being killed in Southeast Asia. Another march of 6,000 people took place in February 1970. In August 1970, the National Moratorium Committee swelled the Los Angeles demonstration to between 20,000 and 30,000 people. Attacked by sheriff's deputies, the march was dispersed with tear gas and, in a related incident, *Los Angeles Times* reporter Rubén Salazar was killed. Victims from the attack were carried to the East Los Angeles Doctor's Hospital where, a year later, Frank Martínez of Mechicano Art Center painted an unfinished fresco picturing Rubén Salazar surrounded by children, pre-Columbian art, and folk motifs. Reconstructed in mosaic, the mural was mounted on an outside wall of the hospital within two years. The same theme was repeated in 1973 by Willie Herrón and Gronk in their Estrada Courts black-and-white mural with a photo-derived image of the sheriffs outside the Silver Dollar Cafe where Salazar was killed. In 1974, Sergio O'Cadiz of Orange County, working with fifty Santa Ana College students and three professionals, painted a memorial tombstone to Rubén Salazar in a section of the Neally Library mural History and Evolution of the Chicano in the United States. Salazar's tomb appears under a crucified Indian which was "quoted" from Mexican muralist David Alfaro Siqueiros' 1932 whitewashed mural in Olvera Street, *Tropical America*, to suggest the parallel martyrdom of Salazar. [22]

 As the city (and county) with the largest Mexican population in the United States, Los Angeles also counts with the largest number of Chicano murals in the country. In the

20. Manuel Unzueta, *Murals Art Murals Art* (Santa Barbara, CA: Casa de la Raza, n.d.).
21. Armando Vallejo, "Murales en progreso," *Xalman,* 3, no. 1 (1980): 24-37.
22. See the brochure *The MEChA Mural: Tenth Anniversary, 1974-1984*, text by Shifra M. Goldman (Santa Ana, CA: Rancho Santiago Community College District, 1984).

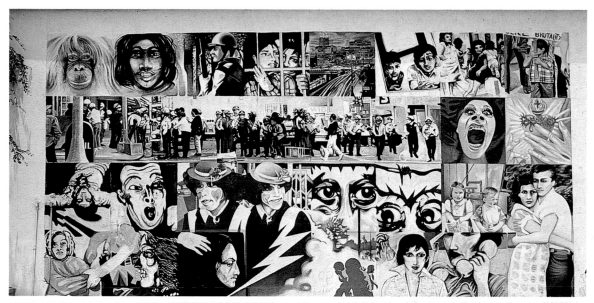

BLACK AND WHITE MORATORIUM MURAL
1973
Willie Herrón and Gronk
Estrada Courts Housing Project, East Los Angeles
approx. 20' x 30'

1970 to 1975 period, most were painted under the sponsorship of several important organizations and agencies: Mechicano Art Center, the Goez Gallery, the Cultural Arts Section of the Department of Recreation and Parks (1971) — which in 1973 established the Inner City Murals Project (both multiethnic) — the City Council-funded Citywide Mural Project established by Judith Baca in 1974, and, finally, Baca's non-profit Social and Public Art Resource Center (SPARC) set up in 1976. In addition, there were individual muralists and small groups who worked within and without these structures, raising money (or working without pay), in various ways.

The most notable individual is Charles "Gato" Félix who, though associated with Goez Gallery, single-handedly organized painters (including himself) to create murals with the community throughout the 1970s (beginning in 1973) at the City Housing Authority's project, Estrada Courts. Félix had as an example the murals painted earlier at the Costello Recreation Center by Las Vistas Nuevas, directed by Judith Baca. His financing was of the most meagre (or non-existent) variety. Murals at Estrada were done with or without teams, by professionals, and

by self-taught painters. In addition to Félix, there were Gil Hernández, Alex Maya, Roberto Chávez, David Botello, Sonny Martínez, The Muralistics, Richard Haro, Manuel González, Norma Montoya, Frank López, Willie Herrón, and Gronk. The Congreso de Artistas Chicanos en Aztlán from San Diego, led by San Dieguen Mario Torero, painted a mural of Ché Guevara with the slogan "We Are Not a Minority." [23]

Mechicano Art Center — which in 1971 moved to Whittier Boulevard near to and with the aid of the Doctor's Hospital (a constant patron of Chicano art) after a year on "gallery row" in West Los Angeles — not only provided "open walls" for artists in its galleries, but also taught community silkscreen classes and painted murals. Until 1976, when it closed its doors at another location, Mechicano was, for Los Angeles, the equivalent of the Galería de la Raza for San Francisco. Directed for many years by Leonard Castellanos, Mechicano was the artistic home and nurturing medium for artists like Frank Martínez, Frank Romero, Lucila V. Grijalva, Armando Cabrera, Leo Limón, Carlos Almaraz, William Bejarano, Ismael "Smiley" Cazarez, and veteran artist David Ramírez — all of whom produced or directed murals. Mechicano's walls and sidewalk were decorated with changing murals by Mexican artist Antonio Esparza, Susan Saenz, Ray Atilano, Martin Martínez, Limón, and Cabrera. Castellanos was also devoted to super-graphics which he painted in the neighborhood and with a team on the outdoor stairs opposite Echo Park. (None of these murals exist today.)

In 1973, Mechicano met to plan some twenty proposed murals in Los Angeles neighborhoods. By this time, the group had experience with a competition funded by the Doctor's Hospital to paint the backs of bus benches (1971), and had received mural funding from the National Endowment for the Arts and the City Housing Authority. In the early 1970s, murals were often welcomed as a means of graffiti-abatement by governments and businesses alike. Though Chicano artists agreed to paint murals over graffiti, among themselves many considered the graffiti as an art form and integrated it into or near their murals. (For example Herrón and Gronk in a City Terrace mural; and Carlos Almaraz at the All Nations Neighborhood Center. In contrast both Mechicano, and artist Frank Romero, used spray cans for graffiti-type mural paintings.)

Mechicano directed the painting of murals near and within the Ramona Gardens Housing Project from 1973 on. Among the artists were Joe Rodríguez, Manuel Cruz, Wayne Alaniz Healy, Judith Hernández, Willie Herrón, Limón, Cabrera, Cazarez, and Almaraz. By 1974, Almaraz was part of Los Four, a group organized by Gilbert Sánchez Luján which also

23. This mural was twice vandalized (the last time in 1984 immediately prior to the Olympic games by a Cuban group) and twice restored by Charles Félix.

included Roberto de la Rocha and Frank Romero. They were joined by Judith Hernández, and still later by John Valadez — both of whom were muralists — and produced murals as individuals and as a group.

Other mural painting teams included the vanguard group ASCO, two of whose members, Willie Herrón and Gronk, started painting murals in 1972, individually and collectively. Abetted by Patssi Valdez and Harry Gamboa, Jr., ASCO iconoclastically lampooned all murals by producing "instant murals" (such as taping Valdez to a wall) and "walking murals" (with costumes and masks) as a form of performance art. The two-man team, Los Dos Streetscapers (Healy and David Botello), enlarged their group with George Yepes and became the East Los Streetscapers, producing fixed and portable murals in Los Angeles and other cities.

In 1976, Baca — under the auspices of the Social and Public Art Resource Center — began what was to be the longest mural in Los Angeles, possibly anywhere: *The History of California,* also known interchangeably as the *Great Wall of Los Angeles* or the *Tujunga Wash Mural.* Carefully researched, and drawing on the skills of many people over the years, the *Great Wall* has been done in segments starting with 1000 feet and continuing with 350 feet every summer for 1978, 1980, 1981, and 1983. It follows California history from the prehistoric dinosaurs, the Indian settlements, the Spanish conquest, and the migration of Blacks, Mexicans, Chinese, Japanese, and whites to California, but at the same time rewrites that history. Sections of the mural deal with the U.S. conquest of the Southwest, women's suffrage, World War I, the growth of Hollywood, the Great Depression, World War II, the fight against fascism abroad and racism at home, the Zoot Suit Riots, Japanese internment camps, Jewish refugees, labor organizers and the social reverses for women, progressives, and people of color in the 1950s. It continues with the ethnic origins of rock and roll, the history of gay and lesbian rights, the Black civil rights movement, the emergence of the Beat movement, the forced assimilation of Native Americans, and, finally, the images of Olympic champions from 1948 to 1964 — especially champions of color, and women. Baca is considering adding to the mural, which now measures over 2400 feet long by thirteen feet high, and updating its historical component. (Among the Chicana artists who have worked with Baca on the mural are Judith Hernández, Olga Muñiz, Isabel Castro, Yreina Cervántez, and Patssi Valdez.

Space does not permit a listing of all the artists, to say nothing of all the murals, in Los Angeles. It is estimated that there were 1000 throughout the city in 1978,[24] of which,

24. Barnett, p. 166, citing a Citywide Murals press release, July 1978.

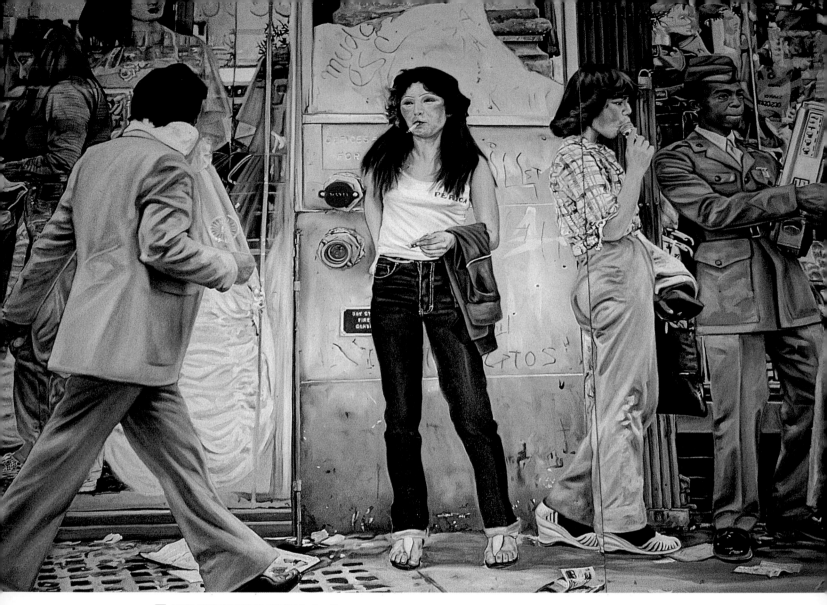

THE BROADWAY MURAL, detail
1981
John Valadez
Victor Clothing Company, interior
742 South Broadway, Los Angeles,
8' x 60'

without question, the greatest number were Chicano-painted or directed. As of this writing, over ten years later, the quantity has risen.

There has, however, been a drastic curtailing of mural production in Los Angeles since the 1971 to 1975 groundswell. Most self-taught artists have retired from muralism (or art) altogether. Among the professionals, artists have turned to other artistic modes. Of those still doing murals, especially worthy of mention (in addition to Judith Baca with SPARC) is the Victor Clothing Company complex of murals in downtown Los Angeles. The building at 240 S. Broadway (now an artists' haven) had long been adorned with a several-story mural by Kent Twitchell of a bride and groom, and a mural inside Victor's Clothing store on an indigenous theme. After John Valadez moved to a loft studio near Victor's Clothing, he began working on *The Broadway Mural*, originally a 48 x 8 foot oil on canvas mounted on eight 8 x 6 panels. Later expanded to 60 feet, it was installed in 1981 above eye level inside Victor's. Based on Valadez's immersion in, and photography of the buildings, stores, and crowded streets of shoppers on Broadway, the mural is an aesthetic and social achievement equal to Berkeley's *Song of Unity* in 1978. After the Olympics, three murals were added to the same building: next to Twitchell's work, the East Los Streetscapers did a huge mural on sports. On the Third Street side of the building, Eloy Torres executed a gigantic photorealist portrait of actor Anthony Quinn, and Frank Romero designed a brightly colored and joyous image of a galloping horse and rider.

Orange County. Two artists are responsible for the most important murals of this area: Mexican-born and trained Sergio O'Cadiz, and Emigdio Vásquez who has lived since 1941 on Cypress Street in the city of Orange. Since the 1960s, he has painted the urban experience of working people in the *barrio*. In 1973 O'Cadiz painted a semi-abstract 40 x 12 foot mural using as main motifs the eagle and the jaguar. These appear on the facade of the James Monroe Elementary School in Santa Ana. He also directed the 1974 MEChA mural at Santa Ana College, for which Emigdio Vásquez painted the *Pachuco* section. In 1975, O'Cadiz directed an enormous mural in Fountain Valley, an old Mexican *barrio* which had been walled off from a modern Anglo town by a 600 foot concrete wall.

Vásquez himself painted *Recuerdos del pasado y imagenes del presente* (Memories of the Past and Images of the Present) in 1978, a mural which traces Mexican history from Zapata to Cesar Chávez. In 1979, he painted *The History of the Chicano Working Class*. Commissioned by the city of Anaheim, Vásquez continued with a series of murals painted with young people among which are a *History of Anaheim* and, most notably, the 6 x 106 foot mural *Nuestra Experiencia en el Siglo XX* (Our Experience in the 20th Century; 1980) on a Salvation Army parking lot wall. This last work begins in 1910 with images of Flores Magón, Zapata and the Mexican Revolution,

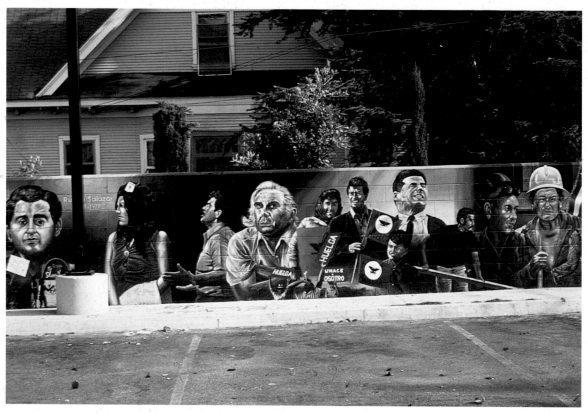

and visually follows the history of the Mexican/Chicano peoples and their heroes and heroines of the 1960s and 1970s. Not only is Rubén Salazar included, but also Bert Corona, intellectual and activist from the 1950s to the present in the Los Angeles area — a hero whose image has appeared in no other mural to my knowledge. In more recent years Vásquez worked as muralist-in-residence for Bowers Museum, and for Rancho Santiago College, both in Santa Ana. For a period of time, Manuel Hernández-Trujillo, co-founder of MALAF in 1969, painted murals and taught muralism at the University of California, Irvine, in Orange County and Judith Baca has been teaching a mural class at the same institution since 1981.

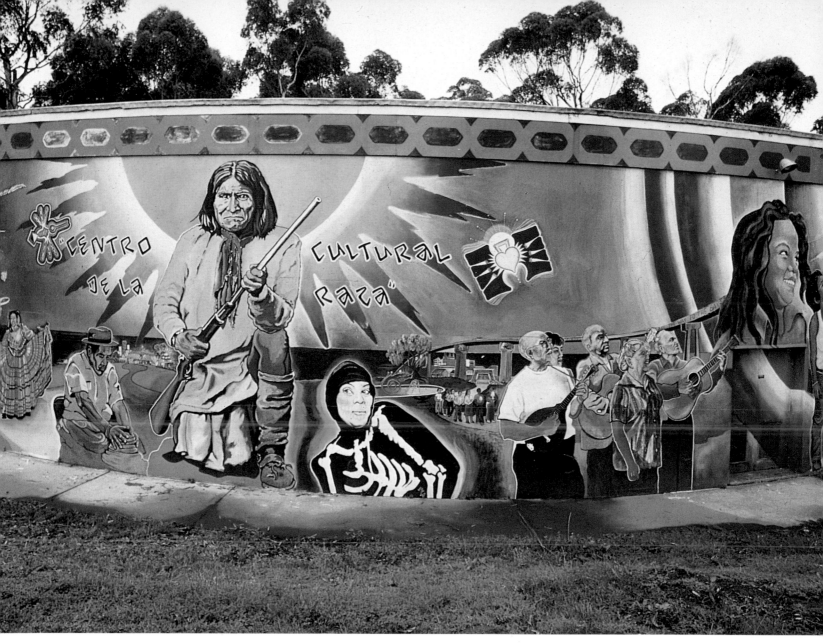

GERÓNIMO
1981
Victor Ochoa
Centro Cultural de la Raza, Balboa Park, San Diego
15'9" x 60'6"

San Diego to the Mexican Border. Unlike other areas, the two major sites of muralism in San Diego — Chicano Park and the Centro Cultural de la Raza — have been the subject of lengthy historical studies: Eva Cockcroft's "The Story of Chicano Park," and Phillip Brookman's "El Centro Cultural de la Raza, Fifteen Years." [25] Therefore, we can introduce materials on the San Diego area murals in a more abbreviated way. Chicano Park was constructed under the terminating structure of the Coronado Bridge which spanned the Bay beginning in 1969. The bridge, built for middle class commuters to the mainland, bisected and threatened to destroy the Logan neighborhood. In 1970, the Chicano community claimed the land beneath the bridge as a park and planted it with trees and flowers — thus making it into "liberated territory" in the spirit of other people's parks of the 1960s. Since 1973, its pillars have been painted by artists from San Diego and many other parts of California, and it remains a living symbol of unity for the community. Not only are new murals regularly added, but a comprehensive restoration project is underway to refurbish those that have suffered the results of weathering.

One of the leading spirits of Chicano Park since its inception was Salvador Robert "Queso" Torres, who was educated in the 1950s at the College of Arts and Crafts in Oakland at the same time as José Montoya and Esteban Villa. Beyond the question of muralized pillars, Torres has had a long-standing interest in the park as an environmental project involving its extension into the water under the bridge. The low retaining walls of the freeway were the first areas painted by Torres, Guillermo Aranda, Victor Ochoa, Armando Nuñez, Abrán Quevedo, Salvador Barajas, Arturo Román, Guillermo Rosete, Mario Torero, Coyote, and Joe Cervantes. Pillars were painted by local and invited artists: groups came from Santa Ana, Los Angeles (Charles Félix), and Sacramento (members of the Royal Chicano Air Force). To the local artists over the years were added Felipe Adame, Pablo de la Rosa, Felipe Barbosa, Mano Lina, Louie Manzano, and many others. A second set of pillars in 1977-78 (during the Muralthon) were painted by Tony de Varga, Socorro Gamboa, and Anglo artist Michael Schnorr. Many murals were painted with the assistance of community activists and students.

El Centro Cultural de la Raza also has a long history. Its establishment was due to the need for artists, dancers, poets, and actors to have a space of their own. In 1971 under the guidance of poet Alurista, and of Torres, the Toltecas en Aztlán acquired, through persistent community-based demands, the round building in Balboa Park which is the present Centro. The first mural was begun in the interior by Aranda working with a team, and was finally finished

25. Eva Cockcroft, "The Story of Chicano Park," *Aztlán*, 15, no. 1 (Spring 1984): 79-103; and Philip Brookman, "El Centro Cultural de la Raza, Fifteen Years," in *Made in Aztlán*, ed. Philip Brookman and Guillermo Gómez-Peña (San Diego: Centro Cultural de la Raza, 1986), pp. 12 - 53.

in the mid 1980s. The outside murals, some of which have changed over the years, are by Mario Aguilar, Aranda, Barajas, Arturo Román, Neto del Sol, David Avalos, Antonio de Hermosillo, Samuel Llamas and Antonia Pérez. Victor Ochoa, the one Chicano artist who has consistently worked on murals throughout the years and served in multiple capacities, painted the image of Gerónimo which replaced a huge *calavera* on the streetside curve of the wall. Ochoa, in addition to murals at the Centro and Chicano Park, has painted with groups in Sherman Little Park, at the Balboa Elementary School, in Oceanside, and many other locations. San Dieguans consider their "turf" to include all the area from the city to the Mexican border—and beyond. The latest group to be organized from the Centro has been the Border Art Workshop/Taller de Arte Fronterizo which promotes cultural events between San Diego and its sister city in Mexico, Tijuana.

■ CONCLUSIONS

It is obvious that many locations, murals, and artists have been left out of this account. What has been attempted has been a general overview of mural production, geographically organized; a recounting of the participation of numerous artists; the dynamics of interaction between individuals and the infrastructures they established to carry out their projects; and the response to local and world events by Chicano artistic communities.

The eighties, starting with the Carter administration, have been framed by a swing to right wing politics in government, and a worsening economic and political situation for the majority of North Americans that is particularly oppressive for peoples of the Third World living in the United States. These conditions are accompanied by the threat and practice of continental warfare that could escalate into an international nuclear encounter. Social services have been cut to the bone causing tremendous suffering, and there has been a reversal of many gains won by labor and working people during the last fifty years. Support by government for community and grassroots art projects has also been drastically cut, and the situation worsened under the Reagan administration which fostered a "small business" approach for artists and advocated support to the arts by large corporations and foundations. The consequence of such support often leads to subtle, and not so subtle, censorship and to self-censorship in the form of decorative solutions to murals. Ironically, the interest of mainstream institutions in Chicano and "Hispanic" art production in recent years has had the centrifugal effect of forcing collectives apart, of engendering elitist competition and individualism (the old "every man for himself" syndrome.) Combined with funding difficulties, these new attitudes can have a serious adverse effect on community murals. For those courageous and dedicated muralists who continue to paint meaningful works in the face of adversity, we owe our support and assistance.

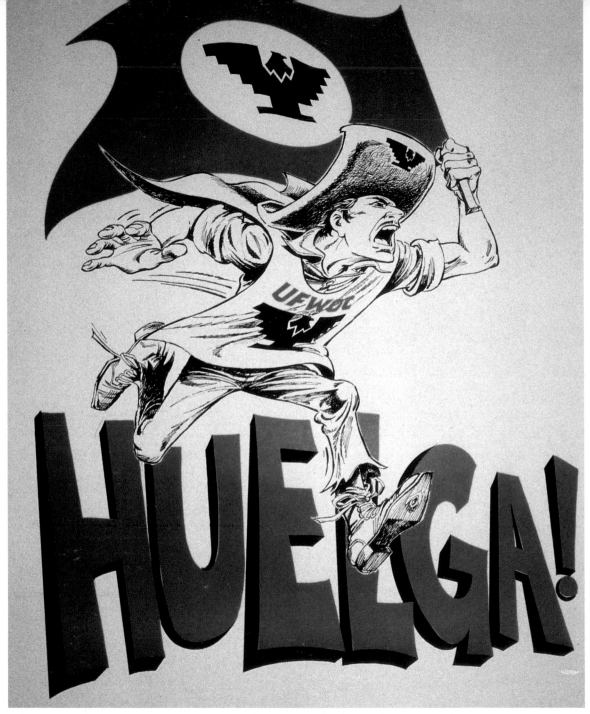

HUELGA
1965-70
Andy Zermeño, Taller Grafico of the United Farm Workers
photo offset poster

Tomás Ybarra-Frausto

Arte Chicano: Images of a Community

At significant junctures in our human development we ask and respond to fundamental questions concerning our self-identity, our history, and our future. The same questioning occurs within groups of people at particular moments in their historical trajectory. For Mexican-descended people in the United States, the 1960s was such a period of introspection, analysis, and action. Multiple socio-political mobilizations brought forth issues of deep resonance within Mexican American communities throughout the country. Rural agrarian struggles, urban civil right confrontations, student activism and myriad other battles for self-determination and cultural reclamation coalesced into a collective national consciousness known as the "Chicano Movement." The repertoire of varied political responses reflected a heterogeneous community united by social positioning of class, race and ethnicity which cut across generational and regional lines.

Among the common denominators were the facts that most Chicanos belonged to the working class, that they maintained variants of a generalized Mexican culture, and that all had the experience of living in the United States. Also they were mainly a young population working and living throughout the country in the Northwest, Midwest and Southwest.

Inscribed within a social nexus of exploitation and disenfranchisement, Chicanos asserted their historical imperative as generators of culture rather than mere receptors of cultural expression from the dominant culture. Reclaiming their imagination, they proclaimed their self invention within an aesthetic project that linked visual artists, poets, musicans, and dancers to the various political fronts of *el movimiento*.

■ THE CHICANO AESTHETIC PROJECT

An initial task was to re-think representation, the role of the artist, and the social function of art. In opposition to the dominant culture, the Chicano had been conceived as the "other" and reduced to a system of ideological fictions in North American culture. Configurations of the "other" always included themes of backwardness, degeneracy, and inequality. As Chicano visual artists countered the external visions and commenced to create vital and positive visions of themselves and their environment they provide a challenge to orthodox, hierarchical culture by positioning a more democratic forum with open participation. Individuals could be both workers and artists. In fact, the visual artist was seen as a sort of cultural worker. Art was necessary but not privileged or special. Visual experience was thought to stimulate the viewer to fuller comprehension of the complex human environment and the social needs of people within it.

Remaining outside the official cultural apparatus, Chicano artists organized alternative circuits to create, disseminate, and market their artistic production. The interpretive community, those who decide what counted and had value as art were often the artists themselves. Going against the normative traditions of art as escape and commodity, a prevalent attitude towards Chicano art objects was that they should provide aesthetic pleasure and delight while also serving to educate and edify.

■ ALTERNATIVE FORMS AND SPACES

Unified by the shared intention of using art as part of the struggle to achieve new and more credible human values, Chicano artists by the mid-1970s had become producers of visual education. Murals, billboards, posters, easel paintings, and new forms of communal ceremonies all served to establish a code of visual signification that was meaningful, commonly understood, and collectively validated. Reflecting a multi-cultural reality, Chicano art amalgamated and united elements from both Mexican and Anglo American artistic traditions. This artistic syncretism corresponded to the historical *mestizaje* of the Chicano and provided artists a vast repository of subject matter and a wide repertoire of styles.

Beyond the formulation of aesthetic models, the artistic community began the arduous task of creating a viewing audience. Recognizing the "high art" system with its norms of privilege and exclusion would be intolerant to Chicano art, a non-art world centered network of support and information was established. Exhibitions were not to be mounted in museums or galleries but rather in community sites such as parks, storefronts or meeting halls. Art was integrated with political rallies, *barrio* social events, and community cultural celebrations where viewers were encouraged to interact with the art and artists. Exhibitions promptly became

communal celebrations in comfortable environments where art was demystified and given an accesible ordinary dimension.

■ A NEW ART OF THE PEOPLE

Having codified the role of the artists as a visual educator, having structured an alternative art circuit for production and distribution, and steadily working to create an audience, the fundamental task was to elaborate *un nuevo arte del pueblo* (a new art of the people) created from shared experience and based on communal art traditions. Necessarily, a first step was to investigate, validate, and incorporate authentic expressive forms arising within the complex and multi-faceted Chicano community. In opposition to the hierarchical dominant culture with implicit distinctions for "fine" and "folk art", attempts were made to eradicate boundaries and integrate categories. An initial recognition was that everyday life and the lived environment were the prime constituent elements for the new aesthetic.

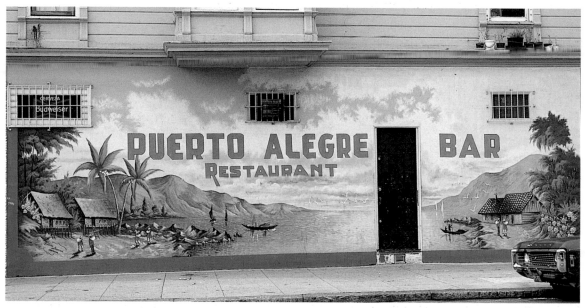

PUERTO ALEGRE BAR
1980s
Cordova
Mission District, San Francisco
approx. 10' x 25'
A *pulqueria*-type mural.

*SACRED HEART
OF JESUS*
20th century
Anonymous
Mexican lithograph
9" x 12"

Cultural practices of everyday life were seen as nutrient sources for Chicano art forms. As *barrio* customs, rituals, and traditions were investigated, they yielded boundless sources of imagery. Many communities have long supported Spanish language newspapers (like *La Opinion* in Los Angeles) in which artists have created a vigorous traditon of satirical caricature and illustration. These graphic traditions were now continued in the Chicano Movement press. Large scale outdoor painting (murals) in the exuberant style of Mexican *pulqueria* art often decorate *barrio* groceries, meat markets, restaurants, and bars. Created and signed by skilled commercial artists, such paintings can be nostalgic (an evocation of a Mexican village), humorous (a butcher shop with a frieze of little pigs dressed as chefs and cooking humans), historical (a restaurant with panels depicting heroes of the Mexican Revolution) or informational (a bar named "La Sirena" with a facade featuring cavorting mermaids, Neptune, sea nymphs and assorted sea creatures). Painted in brilliant color with simple compositional schemes and a direct rendering of forms, Chicano *pulqueria* type art is a colorful and charming ongoing tradition of art in public spaces; it is lively, witty, and often rhetorical. The historical panels from this tradition are especially significant in the develpment of Chicano murals. Opposed to the decorative *pulqueria* type art which is outdoors, the historical panels were painted indoors in restaurants or community meeting halls, places where families gathered. These panels were self-contained pictorial renderings of historical events such as the Battle of Puebla (in the 19th century) or the legend of Cuauhtemoc (an Aztec hero of the 16th century). Functioning as didactic tools, they served as visual reminders of the historical past.

Another pervasive form of popular art in the barrio is the yearly issued *almanaque* (chromo-lithographed calendar) given to customers by local merchants who commission them as promotional materials. Although created as advertisements to sell products, the *almanaque* traditionally excludes the product from the visual itself. Rather, the plates feature Mexican genre scenes such as evocations of *milpas* and *ranchitos* (agrarian landscapes), *charros* and their senoritas, indigenous myths, and the full pantheon of Mexican national heroes. The Virgen de Guadalupe is another preferred image in the *almanaques*. Often the calendar illustrations are saved from year to year and displayed in the household like contemporary posters.

Since the Catholic religion is a paramount influence in the lives of most Chicanos, it is natural that artists gain imspiration from religious imagery and practices. *Estampas* and *altares* have been a direct iconographic influence in the work of many Chicano artists. *Estampas* are chromo-lithographed religious images that are sold in *barrio* stores or dispensed by church groups. They are vividly embellished depictions of favored images such as El Sagrado Corazon de Jesus (the Sacred Heart of Jesus), El Santo Niño de Atocha (the Holy Child of Atocha), La

*WHERE HEROES
ARE BORN*
1983
Juan Orduñez
3881 No. Broadway
East Los Angeles
6' x 20'

Virgen de San Juan de Los Lagos (the Virgin of San Juan of the Lakes), and myriad others. Inexpensively or elaborately framed, such images stand in almost every room of Chicano homes. Each saint has an accompanying tale, and many young children are enthralled by the oral renditions of their ancient and heroic exploits. Indeed, the saints in the *estampas* are often regarded as cultural heros. Having such an impact on the imagination, it is no wonder that *estampas* emerged as primary sources of Chicano imagery found in murals and other art forms.

In the ongoing assessment and re-interpretations of *barrio* culture, many artists focused on *altares* (home religious shrines) as expressive forms which typified the confluence of tradition and change. They are environmental pieces that project continuing cultural and spiritual statements. In their creative eclecticism, *altares* reflect particular concepts of beauty, orthodox religious and spiritual beliefs, and display treasured objects deriving from significant events and situations in the lives of their creators.

In Chicano homes, they served as part of daily life. Typical constituents might include crocheted doillies and embroidered cloths, family photographs, *recuerdos* (personal momentos such as flowers or favors saved from a dance or party), *santos* (religious chromos or statues) especially venerated by the family, and a melange of many other elements. The grouping of the various objects in a particular space — atop the television set, on a kitchen counter, atop a bedroom dresser, or in a specially constructed *nicho* (wall shelf) appear to be random, but usually respond the a conscious sensibililty and aesthetic judgement of what things belong together and in what arrangement.

By the mid-1970s in the thrust to foment a *nuevo arte del pueble*, Raza artists began the process of investigation and reintegration with vast resources of *barrio* popular art. One necessary cultural task was to demonstrate how the Chicano community had maintained and adopted elements from Mexican folk culture. *Almanaques, altares, estampas* and *pulqueria* type art were appropriated as examples of cultural continuity and adaptation. There was also a conscious effort to validate expressive forms specifically rooted in the American urban experience. The style, stance, and visual discourse of sub-cultures within the Chicano community were also ac-knowledged as generators of specific art forms. Placas (spray painted gang graffiti), *tatuajes* (india ink tattoos made with improvised needles), customizing of *ranflas* (low-rider cars), youth gang regalia, *pinto* (prison) art such as *panuelitos* (ballpoint or pen and ink decorated handkerchiefs), the self-presentation of *cholos* and countless other expressive forms evoke and embody a *barrio* sensibility — a sense of self worth that is defiant, proud, and rooted in resistance.

While learning and drawing inspiration from contemporary *barrio* expressions, Chicano artists also began the task of reclaiming artistic traditions rooted in ancestral heritage.

Sculptors especially found historical affinities in the *santero* and *penitente* art of the Southwest. The potent *santero* traditon has ebbed and flowed but continues as a vital contemporary idiom. *Santos* are sculpted or painted representations of Christian saints often anonymously created by self taught or semi-professional artists. When carved in the round either in separate sections or in a single piece, the image is called a *bulto*; when painted on wooden panels, it is a *retablo*. *Santos* were ordinarily used in the home or in local churches as objects of veneration. Although functioning as religious icons, they were given human dimensions and integrated as art objects within the everyday life of the home. Chicano artists seeking to relate their work in a direct way with community concerns gained impetus from this historical antecedent of an art form developed and nourished directly within a social context.

The *Penitente* Brotherhood, a secular religious order, was another significant force in the formation of a durable artistic expression in the Southwest. *Penitente* art most often portrays Christ in his Passion through life-sized, realistic statues of the Ecce Homo (sorrowful Christ). Other typical *penitente* subjects are the skeleton or death *vanitas* figures representing the folly and transience of human life. Forceful examples are the *caretas de la muerte* (death carts) which contain powerful images of death affectionately known as Doña Sebastiana. The striking imagery and emotive power of *penitente* art had a profound impact on those Chicano artists forging an art which sought to communicate content with integrity.

In *penitente* art, careful attention to precise detail is secondary to the more significant "expressive" qualities often transmitted by distortion and exaggeration. Vigorous coloration, crude texture, and rhetorically simplified forms aid in creating the passionate mood of *penitente* sculptural figures. These stylistic aspects could well be related to the socially conscious mural art being created in California. Contemporary Chicano art, much of it full of indignation and outrage, could claim rightful affinity with the emotively charged antecedent expression of *penitente* art.

Knowledge about the Indo-Hispanic art forms of the Southwest came neither from academic or scholarly sources. It was gained from sources within the movement like *El Grito del Norte*, a newspaper issued from Española, New Mexico starting in 1968. This journal had a grass-roots orientation and placed a major emphasis on preserving the culture of the rural agrarian class. Often, photographic essays focusing on local artisans or documenting traditional ways of life in the isolated *pueblitos* of northern New Mexico were featured. Cleofas Vigil, a practicing *santero* from the region, traveled widely speaking to groups of artists banding together to form the nascent Chicano arts movement. The carvers Patrocinio Barela, Celso Gallegos and Jorge López, all master *santeros*, whose works were collected, documented, and exhibited by Anglo

DOLOR
1979
Ralph Maradiaga
Galería de la Raza/Studio 24
silkscreen
24" x 30"

ABAJO CON LA MIGRA
1979
Malaquías Montoya
black and white silkscreen poster
24" x 30"

In the spontaneity and spirit of the festival, the community has time to speculate and take cognizance of itself and its cultural traditions. The new forms of communal celebrations functioned as artistic strategies to symbolically transmit key assumptions of the Chicano art movement. They introduced and propagated many of the symbols, themes, and motifs being codified into a visual vocabulary by Chicano artists. While stressing pre-Colombian and indigenous subject-matter, the emergent visual vocabulary also incorporated urban types and explorations of the hybrid Chicano social milieu.

Integrally related to the human concerns of their local neighborhoods, artists pursued the vital tasks of creating art forms that strengthened the will, fortified the cultural identity, and clarified the consciousness of the community. The foremost aesthetic aim continued to be search for an organic unity between actual social living and art. By the mid-1970s posters and murals were ubiquitous purveyors of visual culture in Chicano communities.

For their visual dialogue, artists soon codified themes, motifs, and iconography which provided ideological direction and visual coherence to mural and poster production. In the main, this artistic vocabulary included referents to pre-Columbian, Mexican, Chicano, Anglo American, and international sources. The search was for a visual language that was clear, emotionally charged, and easily understood

Pre-Columbian citations include pyramids, the Aztec calendar stone, cultural heroes like Quetzalcoatl, and deities like Tlaloc and Coatlicue. From the Mexican heritage references to revolutionary heros and cultural traditions are widespread. Potent cultural symbols like *el maguey*, La Virgen de Guadalupe, and *la calavera* are prevalent. Chicano motifs like *placas* or the *huelga* thunderbird appear constantly with such heroic figures as Ché Guevara and Cesar Chávez. Anglo America provides satirical visions of Uncle Sam, the Statue of Liberty, and caricataures of the bourgeoisie — bosses, landowners, and robber barons. Internationalism entered the pictorial vocabulary of Chicano murals and posters with motifs and iconographic details from the people's struggles in Vietnam, Africa, and Latin America.

Creating a dialectical art is an ongoing process and marks the mature stage of the Chicano art movement in the 1980s. This phase entails the appropriation of the most advanced styles, techniques, and technologies in the persistent, disciplined, and continual effort toward developing an enhanced art of resistance — an art which is not a resistance to the materials and forms of art, but rather a resistance to entrenched social systems of power, exclusion, and negation.

"Zoot Suit Riots", detail, *GREAT WALL OF LOS ANGELES*
1981
Judith F. Baca
Tujunga Wash Drainage Canal, San Fernando Valley, Los Angeles
total mural over 1/2 mile long, this detail approx. 13' x 8'

Amalia Mesa-Bains

Quest for Identity: Profile of Two Chicana Muralists

Based on Interviews with Judith F. Baca and Patricia Rodríguez

The Chicano Movement can be seen as a coming of age, a self-definition rooted in a critical period of development both individual and social. Concerns with improved education, labor conditions, bilingual support, land retrieval, and community empowerment were bound together within the encompassing challenge of identity. For the artist, this self-definition by virtue of its historical placement was the impulse for both personal and collective expression.

In a historical sense, the Chicano Movement could be interpreted as collective action toward cultural, political, social, economic, or educational change. Viewed privately through the self of the singular artist, the Movement was a struggle with past heritage, societal rejection, adolescent contradiction, and inevitably, the need for purposeful ethical enlistment. This need to blend a historical and personal identity as Chicano was a driving force in the social activism of *el movimiento*.

Those individual artists whose developing self was indelibly marked by this experience reflect the larger and more massive quest for identity of their group. According to Erik Erikson in his groundbreaking book, *Life History and the Historical Moment*:

> *A historical period may present a singular chance for a collective renewal which opens up unlimited identities for those who, by a combination of unruliness, giftedness, and competence, represent a new leadership, a new elite, and new types rising to dominance in a new people.*[1]

1. Erik Erikson, *Life History and the Historical Moment* (New York: W. W. Norton & Co., 1975), p. 21.

The Chicano mural movement was a major effort in the expressive arts which expanded these concerns of identity through a public discourse. Murals served as a larger than life visual voice linking communities, narrating missing histories, presenting cultural themes, reappropriating neighborhood space, and creating a new imagery of the Chicano. As a function of identity development, murals provided idealized portraits which celebrated family and cultural practices. Their themes often outlined political demands and spiritual beliefs significant to the larger Chicano community.

Within this mural movement collectives and brigades which sought to develop collaborative models and structures provided important leadership. This leadership was marked by the active presence of women muralists. As women they brought gender perspective to the issues of identity and community; as artists they affirmed a public expression that incorporated both historic and personal narrative. Patricia Rodríguez formerly of the 1970s mural collective, Mujeres Muralistas, is a significant figure in Chicano cultural activity within the movement. Judith F. Baca, creator of the *Great Wall of Los Angeles* continues to be a moving force in mural activities internationally. In looking at the development of these two leading muralists as women, artists, and participants in the Chicano Movement we can perhaps begin to understand the relationship between social and individual identity. Their journey is of an individual and personal nature, yet like a mirror it reflects the life history of a community.

■ PATRICIA RODRIGUEZ

For Patricia Rodríguez the earliest childhood sense of boundaries was of solidity and protection from her own community as well as of exclusion and alienation from an Anglo society. She was born in Texas to a Chicana single parent of the Zoot suit era and was raised by her grandmother while her mother worked. Her earliest recollections were of a racially tense separation between Mexicans and Anglos:

> *We knew that there were certain territories we didn't go into, especially in Texas. It was very close-knit, we had our own barrios and our own districts. In school we got called names and things like that.*

Despite the restrictiveness of the community setting, Patricia Rodríguez' grandmother was able to provide an optimistic model, clearly becoming a source of strength. Her caretaking played a major role in the early development of a feminine identification.

> *She had a lot of strength and energy. She brought me up until the age of seven, so I was molded after her pretty much instead of my mother. She was very productive, very creative... She enjoyed everything about life. She was never bitter, never depressed.*

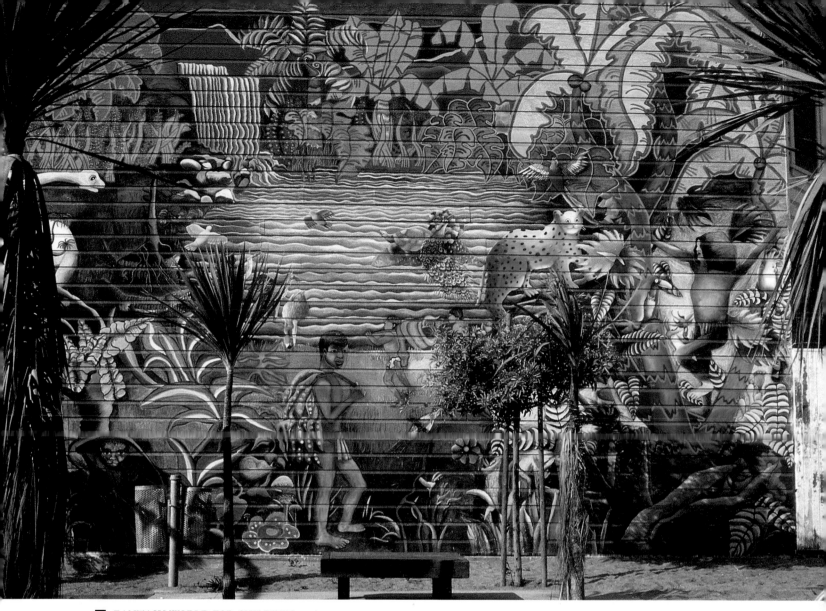

FANTASY WORLD FOR CHILDREN
1975
Patricia Rodríguez, Graciela Carillo, and Irene Pérez
Ralph Maradiaga Mini-Park, 24th and Bryant Sts., Mission District, San Francisco
approx. 30' x 15'

It was in this setting of community culture that Rodríguez experienced those sources that have continued to play a part in her creative identity. The interplay of family gatherings and *barrio* festivities provided an acceptable method of feminine creativity. Through cultural and communal traditions the artist developed a sense of productivity:

> *When I was growing up in the little Texas town, we used to have lots of jamaycas, which are festive days — church celebrations, Mother's day, or something like that — and everybody works toward that day. It's very festive... Women produce a lot of pillow cases, embroidery, knitting, pot holders or aprons or doilies. All that was very colorful, it was a big event. It had a lot of effect on me. I was very excited about what my grandmother was showing and the neighbor was showing.*

This sense of shared expression provided by the nurturing setting of her grandmother's support stirred her first explorations in art making:

> *I can remember being creative ever since I was a child... the earliest thing I can remember is being at a neighbor's house when I still lived with my grandmother in Texas and creating a dress and trying to sew it. Actually, I didn't sew it because when the lady tried to put the dress on the doll, it came apart. But, it was a dress that had two parts to it which was very interesting to her. She was amazed that I could do that.*

The move to California in her childhood allowed Patricia Rodríguez to negotiate a new sense of openess about cultural boundaries. It also provided a conflictual situation as she struggled with the loss of her grandmother, the emergence of a new stepfather and a new community:

> *I came from a very repressive type of background where you just didn't hang out with Anglos — unless they were very poor and they came from the same neighborhoods we came from. In California the division wasn't as blatant. We all hung out together.. It was not easy in the beginning because I didn't know if I should trust them, or whether it was the right thing to do, or if I would get into trouble.*

Adolescent struggles gave way to the opportunity for self-expression under these new influences. During this period, Rodríguez began to formulate a sense of herself as an artist. This ambition was influenced by recognition from others:

> *When I was in junior high I had a wonderful art teacher who was gay and very creative ...He kept encouraging me. He said, "You're going to be an artist. You've got to go to college." And I said, "Well, I've always wanted to be an artist."*

The interaction with a caring adult outside the family served as a bridge to greater aspirations. As for so many adolescents, the interest and concern of a significant teacher provided

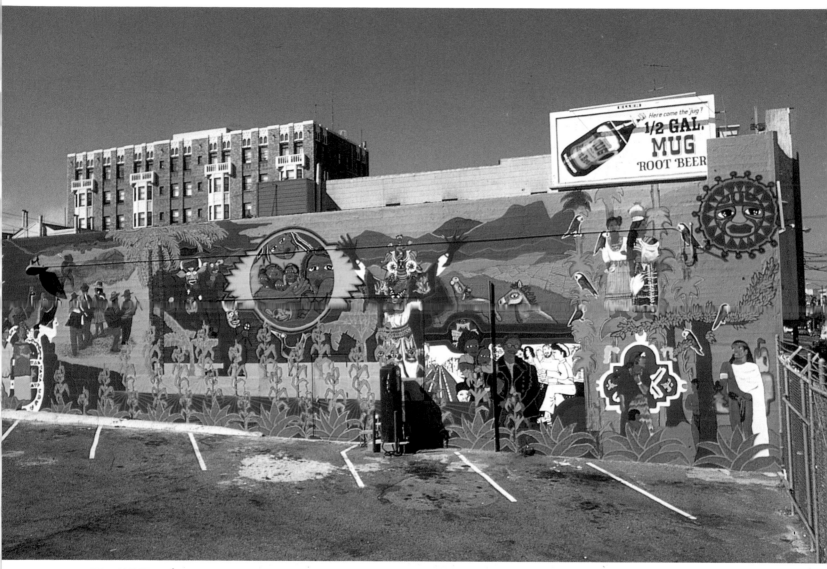

LATINOAMÉRICA
1974
Las Mujeres Muralistas
(Patricia Rodríguez, Graciela Carillo, Consuelo Méndez, Irene Pérez)
Mission Street between 25th and 26th Sts., Mission District, San Francisco
approx. 25' x 70'

You understood what discrimination was about... I felt that I had a responsibility, I had
a duty as part of this younger generation with this kind of consciousness to try and correct
some of those things. It was like enlisting in the army. If I had to have art become part
of that duty for x amount of time, then it would, because it was simply something that I
would have felt terrible if I had not done.

Personal development propelled Patricia Rodríguez toward her own artistic needs and the Chicano collectivity provided a context for social change. Mujeres Muralistas was formed out of a need for women to work together in a supportive way. Like earlier familial models, the Mujeres Muralistas included only women: Irene Pérez (Guatemalan), Graciela Carrillo (Chicano), Consuelo Méndez (Venezuelan), and Patricia Rodríguez. In many ways, the group was also a prototype for the development of movement values which reinforced publicly accessible, anti-elite work of a collective nature. The images of their murals, Latinoamérica and Pacos Tacos, expressed a pan-American aesthetic where highly visible images of women and emphasis on ceremony, celebration, caretaking, harvest and a continental terrain worked toward the creation of a new mythology. The power of the murals relied on precisely that widely held memory of the everyday which allowed the work of the Mujeres Muralistas to provide a recollective function for a broad community during a historic period of time.

■ JUDITH F. BACA

In the period of the Chicano Movement life paths crossed the historic trajectory of the group. Making sense out of this juncture requires us to reflect on the key elements, personal histories, memories, and recollections that marked this experience. For Judith Baca, perhaps it was the story of her own families migration to California shortly before her birth that first made her aware of the oppression and resistance of women. She was reared in a matriarchal family. As for many Chicanos of her generation, her grandmother offered a constant nurturing while her single mother made a living.

My Mother wasn't young when I was born, she was 23. They had been living in Colorado.
The barrio was a very big, very old Mexican community. She had older brothers who
completely controlled her life, a situation which she couldn't bear any more. She made the
journey west. She was the pioneer in the family.

The struggle of this family of women became a model for the artist's later structures of feminist empowerment. Judith Baca was greatly influenced by the character and indigenous sensibility of her grandmother while her mother's working class perseverance in providing for a disabled sister, an elderly mother, a younger sister, and her daughter created a

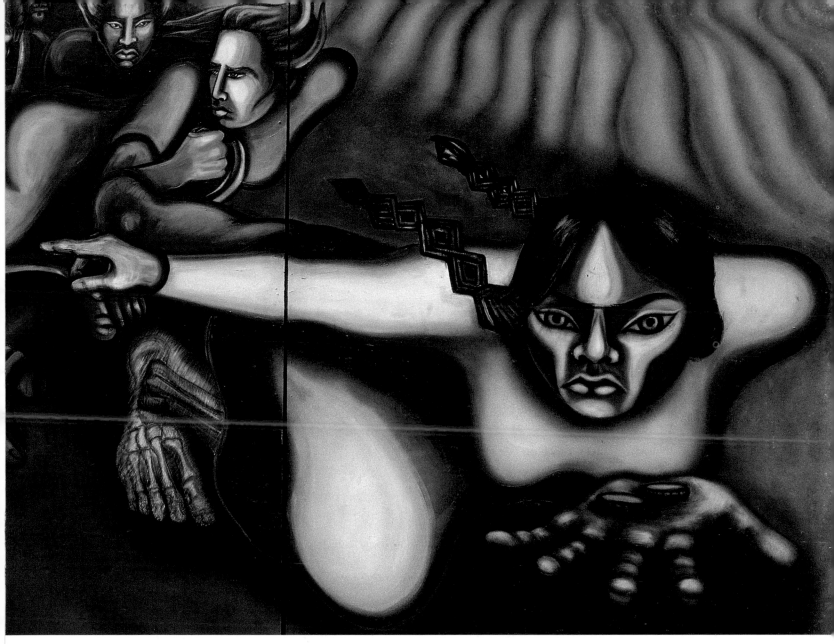

UPRISING OF THE MUJERES, detail
1979
Judith F. Baca
portable, acrylic on wood
8' x 24'

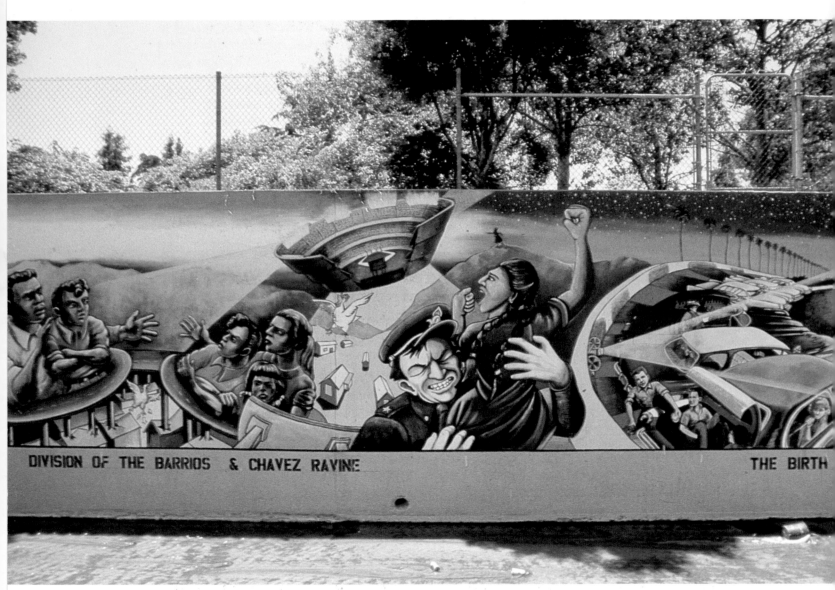

DIVISION OF THE BARRIOS & CHAVEZ RAVINE

THE BIRTH

"Division of the Barrios and Chavez Ravine" from the *GREAT WALL OF LOS ANGELES*
1983
Judith F. Baca
Tujunga Wash Drainage Canal, San Fernando Valley, Los Angeles
total mural over 1/2 mile long, this detail approx. 13' x 35'

If there's a source of pain, I do not avoid it. I think rage and the transformation of it into positive action is one of the great sources of productivity for me. Rage at injustice or at the spiritual disharmony with the earth, with what is female is a starting point from which to develop alternatives. In the subsequent problem solving one thing leads to another. I am part of that process. I really believe that sometimes I'm carried by this great wave of what happens when I put people together.

From Baca's earliest work of organizing youth gangs to do mural work, to the *Great Wall*, to her current traveling piece *The World Wall* (on societal transformation to peace), the artist has been concerned with public space, community empowerment, and creating relationships between discordant people.

One does an analysis of a site and it doesn't matter whether it's East Los Angeles or whether it's Skid Row or whether it's a migrant farm worker's town. In each case you begin with an analysis of that site. And you begin to find out what are the social as well as the physical elements of a particular place...primary, is to really look at the social situation even before the physical side because if the social situation dictates that it is an important site to work at, then even if the physical site is difficult or almost impossible, I may still chance it.

The community participatory process Baca developed, which involves input from historians, cultural informants, storytellers, community residents and young artists, has become an important model for collective murals. The collective process was based on the need to create murals by Chicanos for Chicanos. Consequently, models of community involvement were essential ingredients in allowing the histories and ideas of the murals to reach their intended audience.

Although the collective process draws in many diverse influences, it is Baca's well developed filmic narrative using connecting images that lends the unique quality to works such as the *Great Wall*. She describes its metaphoric quality as follows:

In the case of the Great Wall the metaphor really is the bridge. It's about the interrelationship between ethnic and racial groups, the development of interracial harmony. The product — there are really two products — the mural and another product which is invisible, the interracial harmony between the people who have been involved.

In the long history of California's communities of color conflicts between racial groups are a historic reality. Judith Baca's work serves to bind together disparate histories and adversarial constituencies. In particular, the individual junctures of her life have intersected with the historical moment of the Chicano, Feminist, and Public Art movements. In this respect her life history has encompassed multiple cultural realities. Yet there is a common thread of social

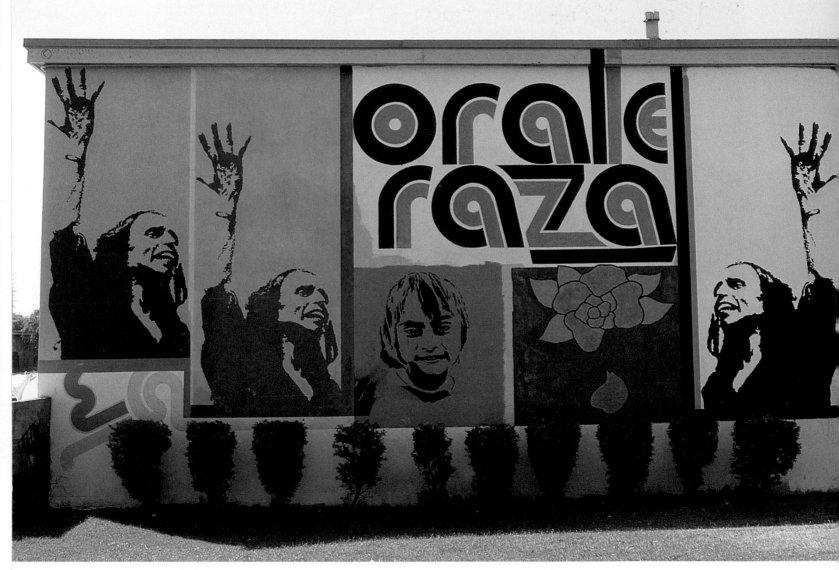

ORALE RAZA
1974
Frank Fierro
Estrada Courts Housing Project, East Los Angeles
approx. 20' x 30'

Marcos Sánchez-Tranquilino

Murales del Movimiento: Chicano Murals and the Discourses of Art and Americanization

A Chicano is a Mexican American who does not have an Anglo image of himself.
— Rubén Salazar, 1970

"ORALE RAZA!," the textual focus of Frank Fierro's colorful 1974 mural at the Estrada Courts Housing Project in East Los Angeles, is an exuberant greeting to all Chicanos. The literal English translation of this greeting is awkward, meaning "Right On! Mexican American People." However, the idiomatic Chicano translation would be closer to "Right on! my People," or even "my Community." The greeting immediately establishes a cultural recognition between the Chicano muralist and the Chicano viewer, acknowledging both as belonging to the national Chicano community. The murals as well as the other arts of this community played a seminal role in the establishment of this important intra-cultural bridge, the effects of which ultimately had significant implications for United States society in general and Chicanos in particular. As with the majority of Chicano murals of its period, "Orale Raza!" articulated a cultural representation of both regional and national political agendas for *el movimiento*, the Chicano civil rights movement which began in the mid-1960s and continued through various transformations into the late 1970s and beyond.

Chicanos (men) and Chicanas (women) representing this new cultural/political identity emerged from the long established U.S. Mexican (or Mexican American) community, and sought to redress their plight through a series of organized political efforts designed to recover their civil rights as American citizens. Towards its goal to effect substantial change, this new community enlisted the assistance of Chicanos on all fronts, i.e. from labor, education, and politics, as well as from the visual and performing arts. The response from everyone was

85

Chicanos within the public arena. As a result, the image of that community was reduced to exotic and romantic portrayals. On the one hand, U.S. Mexicans were perceived as reliable unskilled laborers, family centered, religious, festive, courteous and humble; on the other hand they were seen as representative of the least desirable elements of society, including Mexican Revolution era *bandido*s (thieves) and *cholos* or greasers, the poorest, shabbiest itinerant laborers (with 19th century connotations that they were bums, and in late 20th century terms, destructive urban youth "gang" members). Of course, neither of these caricatured sets of images would allow U.S. Mexicans to be recognized as a community integral to "American" life and culture. This sad assessment was due, in part, to the historical developments of Anglo conquest (Mexican-American War of 1846-1848) and *barrioization* (ghettoization through displacement and disempowerment) of that community by the vested interests of the Anglo culture, aided and abetted by the national media. In addition, the Americanization process had left U.S. Mexicans who would not assimilate without a viable identity that would acknowledge their own particular desire to be both American and Mexican without either identity using its nationalist stance at the expense of its cultural integrity.

It was evident to Chicanos in the early stages of the Movement (mid-1960s) that national self-definition was a primary tool of their efforts towards liberating the U.S. Mexican community from *de facto* internal colonization. The politicized segment of U.S. Mexican society leading this struggle chose "Chicano" as the self-designating term for themselves and the Movement. The term was adopted from the community's *pachuco* (1940s U.S. Mexican zootsuit youth culture) patois.[3] Calling oneself "Chicano" was more than a defiant act directed against older assimilationist generations of Mexican Americans and the dominant Anglo society, it was also a proud assertion of self identity. This seemingly innocuous act had tremendous repercussions within the context of mainstream Americanization practices. The implications of the term "Chicano" as representing a new American identity were not apparent to outsiders. Instead the separatist implications of the term (not Anglo and yet also not Mexican) caused concern for social stability because it further "undermined" the "cultural melting pot" concept of American society.[4] To call oneself Chicano became a political act within the national arena; to publicly greet other Chicanos by exclaiming "Orale Raza!" asserted this act with a cultural pride previously denied to that community in its own country.

3. George Carpenter Barker, "*Pachuco*: An American-Spanish Argot and its Social Functions in Tucson, Arizona," *Social Science Bulletin* (University of Arizona) no. 18, reissued December 1958, p. 19.
4. While the term "Chicano" can be read to signify a separatist stance—and indeed, such an interpretation was encouraged by Chicanos at the time—it can be interpreted simultaneously as a synthesis; as an identity of survival emerging from the meshing of two historically antagonistic cultures.

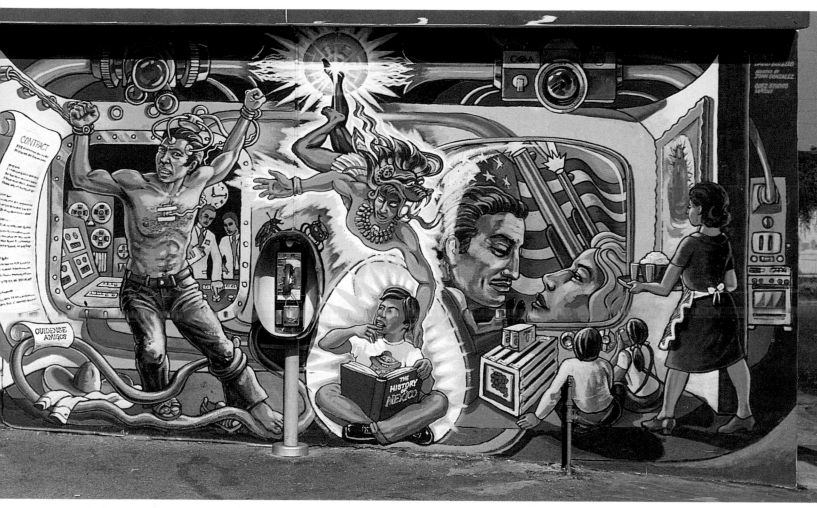

READ BETWEEN THE LINES
1975
David Rivas Botello
Ford and Olympic Blvds., East Los Angeles
10' x 20'

The subsequent recognition by U.S. Mexicans of themselves and their community as "Chicano," was a major prerequisite for achieving social integration into American life on their own terms. The Movement sought change through peaceful interventions; however, its sometimes militant profile was put forth when necessary as the appropriate response to an aggressive Anglo-dominated society.

Like the Black civil rights movement which began in the 1950s, the Chicano Movement beginning in 1965 sought to reclaim the civil rights of Chicanos which had been historically and systematically denied them since the Mexican American War. The denial of civil rights for more than a century to U.S. Mexicans had relegated them to second-class citizenship. By the mid-1960s Chicanos saw themselves as a colonized group disenfranchised from civic, political, and economic opportunity by American social structures. They had become a resource pool for unskilled labor needs as well as draftees and recruits for the Vietnam War.[5]

Through inter-regional networking of urban and rural activists including poets, artists, students, academicians, and others, the Chicano community deployed a nation-wide conceptual structure or Chicano "world view" known as *chicanismo* in order to facilitate the movement towards collective political self-fulfillment. *Planes* or manifestos, such as the Plan Espiritual de Aztlán, were collectively created to set forth the broad philosophical premises for the understanding as well as the practice of *chicanismo*.

In effect, *chicanismo* was a complex of nationalist strategies by which Chicano origins and histories, as well as present and future identities, were constructed and legitimized. Furthermore, it provided a context for historical reclamation of the self through the affirmation of Chicano cultural narratives while resisting Anglo models of assimilation. The renaming of the American Southwest as Aztlán within the national Chicano community was an important initial step in reclaiming the land-base upon which further development of this Chicano world view could take place.

The name Aztlán was borrowed by Chicanos from the 16th century Aztecs who settled in central Mexico. Their seat of power was located in what is known today as Mexico City. For them, Aztlán designated the geographical area of their origin. In their Nahuatl language Aztlán meant "land to the north" among other related interpretations.[6] Chicanos considered this

5. Rodolfo F. Acuña, *Occupied America: A History of Chicanos,* 2d ed. (New York: Harper and Row, 1981), p. 366-367. The percentage of Chicano war casualties at 19.4 of total soldiers killed from the Southwest between January 1961 and February 1967 outnumbered their national representation for the same area of 10-12%.
6. Luis Valdez and Stan Steiner, eds., *Aztlán: An Anthology of Mexican American Literature* (New York: Vintage Books, 1972), p. 401.

northern land to be the American Southwest, and thus the borders of the Chicano Aztlán were perceived to be the same as those of the Aztecs' original homeland. While Aztlán served as the location of the origins for the Aztecs, it now also signified the roots of a 20th century Chicano "archaeology," that is socially identified structures for historical reconstruction and cultural reclamation.

Because U.S. Mexicans had systematically been denied a fair and legitimate role in "American history," they were forced to look outside their U.S. home for one. Due to their ancestral ties they were able to look without any hesitation to Mexico to provide a historical and cultural continuity. In this way, Chicanos were able to establish their own history which was indeed traceable in part through Mexico but more importantly, and ironically, had its beginnings within the borders of what is now the American Southwest. Aztlán mapped out the conceptual and physical territories by which Chicanos could affirm cultural and historical genealogies legitimized by the ancient Mexican past. Besides laying claim to an Aztec patrimony, they were able to claim the culturally advanced civilizations of the Olmecs and the Maya. In the arts, Aztlán fostered the inclusion of infinite philosophical, literal, and figurative references to this pre-European heritage.[7]

Traditionally in this country, U.S. Mexicans involved in the arts could only attain a measure of success by working within the parameters of the "cultural melting pot" fallacy. They, like all artists, were expected to follow, perpetuate and even establish new trends within the confines of what was known as the International (Euro-American) art world, while suppressing any potential references to or acknowledgments of ethnicity in their work.[8] In addition to suppressing ethnicity for fine art purposes, U.S. Mexicans artists also had to avoid or deny ethnic imagery whose meaning had been debased through negative association with derogatory stereotypes of Mexicans — on both sides of the border. These negative images had obtained a wide currency, and ironically a measure of legitimacy on all levels of American culture.

These various forms of cultural suppression, coupled with the fact that Mexicans living in the United States predominantly belonged to an economic class which could not easily afford the luxury of considering art as a profession, served to help validate the popular notion that U.S.

7. To some critics like Juan Gómez-Quiñones it served to immerse the Chicano community into an uncritical romanticized acceptance of the historical past. See Juan Gómez-Quiñones, *Mexican Students por la Raza: The Chicano Student Movement in Southern California 1967-1977* (Santa Barbara, CA: Editorial La Causa, 1978). In the service of projecting a unified national Chicano image, some combinations of historically antagonistic elements such as Spanish conquistadors and Aztec nobles together constituted a deliberate suppression of racial, ethnic, gender, and class difference or even conflict.
8. Quirarte, Preface. Beyond the issues concerning "universal" and "international" art, are the additional ones which identify ethnic art as political. As such it is considered to have less stature and value than so-called "non-political," "non-propagandistic" "universal" art. Further discussion of art and value follows in the text. See also note no. 9.

Mexicans (like other ethnic minorities in the United States) could not produce fine art or a fine art culture. That idea was further supported by the ▓▓▓▓▓▓▓sion of ethnic diversity as part of the mainstream process of producing the "mark▓▓▓▓▓▓▓ure."[9] The fixing of value in this system depends upon a hierarchical structuring which assigns a lower value to art which is not considered "fine" or "vanguard" while assigning a much greater value (and therefore greater social status) to art which is claimed to be of that lofty category. "Fine art" in America could only maintain such a high status if it suppressed any references to ethnicity which would otherwise surely lower its position on the art market value scale to that of "folk" art. Chicano art in general, and murals in particular, generating from a historically specific, community-based context went contrary to this mainstream-supported value hierarchy.

The mainstream media portrayed the Chicano mural movement primarily as one group's colorful attempt to reclaim the decaying American urbanscape. Murals were to be understood mostly as environmental change and not as art.[10] The Anglo-dominated art community contributed to the suppression of Chicano murals as art because they were judged by criteria as defined by Euro-American art traditions in the market place, and supported by academic art historical studies. The art market and academia further contributed to this bias against U.S. Mexicans by virtually ignoring developments in Mexican and Latin American fine arts even within the context of "International" Modern Art.

Striving to meet the needs of the Chicano community through the visual articulation of its newly constructed political positions, the painting of virtually thousands of Chicano murals throughout the Southwest and Midwest were instrumental in the demystification of popularly held notions of Mexican Americans as politically passive and lacking history as well as culture. Much of the work to be done in this arena meant the supplanting of negative images of U.S. Mexicans by portrayals based on a more realistic and complete interpretation of a broader-based and ethnically diverse American history. Muralists became important educators as they painted Chicano contributions to American society not included in school textbooks. Through *chicanismo*, they also highlighted the ancient cultures of Mexico in order to show historical continuity and cultural legitimacy. Throughout, these artists inspired everyone with their sizable talents.

9. Raymond Williams, *Culture* (London: Fontana Paperbacks, 1981), p. 127. The term 'culture' in "the market value of culture" refers to the institutions and practices of music, literature, theater, film, and the visual arts.
10. See, "The Mural Message," *Time Magazine*, 7 April 1975, n.p. An article covering the Chicano murals in East Los Angeles appeared in the "environment" section while the "art" section featured painter Francis Bacon and his current work in New York City.

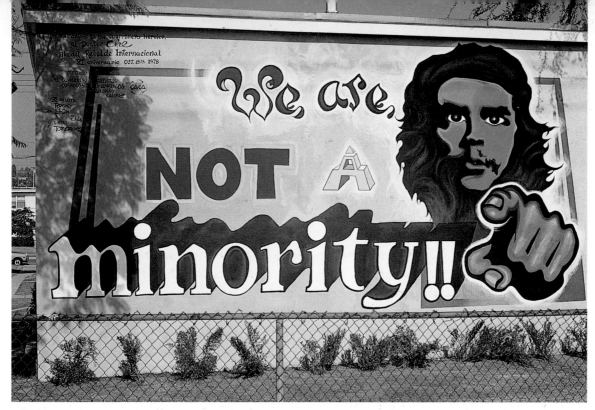

WE ARE NOT A MINORITY
1978
Congresso de Artistas Chicanos en Aztlán
(Mario Torero with Zapilote, Rocky, El Leon, Zade)
Estrada Courts Housing Project,
East Los Angeles
approx. 20′ x 30′

Chicano murals, along with other artistic and political efforts of the Movement, attempted to radically change many of the misperceptions previously mentioned regarding Chicanos, their art, their artists, both within and without the community. Chicano murals go beyond signifying artistic accomplishment, they stand as a testament to the capacity of U.S. Mexicans to organize, plan and direct themselves toward the process of social change and the production of art, including the reconstruction of meaning of their exploited and abused ethnic pre-Chicano period imagery. In particular, the prolific creation of murals represented successful collective efforts on the part of the community toward national self-definition through political and cultural activism. As they put into effect the ideals of Chicano liberation through this organizing process, artists and members of the Mexican American communities served to educate each other, while also educating non-Chicanos.

Throughout the early mural-making period, individual as well as collective efforts at self-definition were given tentative validation by the emerging regional Chicano communities as activists and artists constantly returned to them for affirmation as well as for inspiration and support. The community was the beginning and the end in terms of the murals' articulation of the sources and goals of the Chicano Movement. Perhaps one reason that murals were so abundant so quickly was the all-important reciprocating relationship they enjoyed with the strong early political mobilizations towards the fulfillment of the Movement's immediate goals. On a personal level, it cannot be denied that the Chicano mural movement provided an attractive showcase as well as a training ground where the artists could gain basic and advanced technical expertise (for other art forms as well), while enjoying collective support from their community. Mural making represented the community's public efforts at self-definition in and through an artistic form which did not require validation by the academic, museum or gallery oriented art world. Furthermore, personal commitment to contemporary community-based politics could be affirmed through the organizing of *barrio* residents who participated in the design and execution of the murals. (Often murals could go up only because the artist and his/her crew were paid a nominal fee or donated their labor.) Chicano artists who "returned to the community" sought to experience the new found energy which was fueled by the political idealism of social change. In addition, as Chicano artists worked with their community, they "reclaimed" not only the repressed positive imagery of U.S. Mexicans but also the walls of the *barrios* which had previously served only to restrict them.[11]

These early years of the Chicano mural movement were particularly exciting due to the experimentation continually called for by the emerging unique Chicano mural form. However, the prodigious success of the Chicano mural would not have been possible without the inclusion and participation of thousands of Chicano youth. A study on the making of early murals in East Los Angeles, in particular, has served to demonstrate the dependence on the pre-existing forms and practices of Chicano youth culture in assisting to organize the painting of murals in the Chicano *barrios*.[12] For many young muralists, the long established practice of *barrio*

11. Noted in conversation. John Tagg is a professor of art theory, criticism, and history at the State University of New York, Binghamton. He has published extensively on the development of state/social structures of empowerment.
12. Marcos Sánchez-Tranquilino, "*Mi Casa No Es Su Casa*: Chicano Murals and Barrio Calligraphy as Systems of Signification at Estrada Courts" (Masters' Thesis, University of California, Los Angeles, 1990), n.p. Judy Baca, "Our People are the Internal Exiles," interview by Diane Newmaier in *Cultures in Contention*, ed. Douglas Kahn and Diane Neumaier (Seattle: The Real Comet Press, 1985), p. 65-68. See also, Joan W. Moore, *Homeboys: Gangs, Drugs, and Prisons in the Barrios of Los Angeles* (Philadelphia: Temple University Press, 1978). For further descriptions of youth participation see also: James Diego Vigil, *Barrio Gangs: Streetlife and Identity in Southern California* (Austin: University of Texas Press, 1988).

calligraphy, a highly developed system of artistic standards by which to properly create and appreciate neighborhood "graffiti," played a crucial role in preparing them to reattack the same walls with *movimiento* imagery.

In fact, Chicano murals sprung up wherever there had been a wall displaying this "graffiti." Murals were painted there not to necessarily censor the "graffiti," but because the walls also represented the important locations of effective public communication for a particular segment of youths in the *barrios*. This fact alone sets Chicano murals uniquely apart from vague references to their connections to early 20th century murals done in Mexico. While the Mexican murals were funded, sanctioned and promoted on government buildings (usually painted in the interiors) by a post-1910 Mexican Revolution administration, Chicano murals appeared virtually overnight on the sides of *zapaterias* (shoe stores), *panaderias* (bakeries), *carnicerias* (meat markets), *centros* (community-based art centers), other store fronts, fences, and alleys.

While Chicano murals would continue to demonstrate the strength of a public visual articulation of Chicano liberation into the mid-1980s and beyond, their initial creation and purpose also provided support for a larger art context in the *barrios*. That context played a very important role in the realization for many Chicanos and Chicanas which was that "they could indeed create art." [13] This is a deceptively simple lesson whose value may better be appreciated when one compares it to the long history of artistic and other suppression of the Chicano community. For an artist such as Willie Herrón mural making in East Los Angeles had presented him with particular cultural political challenges which he would continue to address through painting and conceptual performance art, as well as through music as the leader of the critically acclaimed Chicano rock and roll band Los Illegals.

Willie Herrón's mural, *The Wall that Cracked Open*, 1972, sought to infuse a Chicano social consciousness into the potentially self-destructing youth "gang" members of his community, as it also signalled his probing of the limits of the mural form. In order to reach his desired audience, Herrón painted the mural in his neighborhood, in an alley frequented by the young people he wanted to reach.

Although Herrón had previously painted a mural at the entrance to this same alley, *The Wall that Cracked Open*, painted in the middle of the alley, is a poignant personal protest against a local youth gang's brutal beating of his brother, as well as a powerful political protest against the destructive effects of alienation suffered by the city's Chicano community. To provide a more relevant street culture dimension to the mural's content, he integrated his design

13. Gronk, interview with author, Los Angeles, CA, 11 November, 1984.

THE WALL THAT CRACKED OPEN
1972
Willie Herrón
4125 City Terrace, rear, East Los Angeles
25' x 16'

INSTANT MURAL
1974
ASCO Chicano Performance Group
Whittier Boulevard, East Los Angeles
ASCO members Patssi Valdez and Humberto Sandoval
were taped to the wall by Gronk.

of a gang-victimized bleeding young man, fighting youth, and crying grandmother with the "graffiti" already on the wall left by the young barrio calligraphers of the area. By incorporating the Chicano "graffiti" into an "artwork," Herrón initiated a critical rethinking of graffiti as solely signifying vandalism which in turn has led to a deeper understanding of the relationship between so-called Chicano graffiti and Chicano murals.[14]

Through an artistically produced illusion of the mural's victimized subject as well as his attackers breaking through the wall on which they are actually painted, Herrón was able to demonstrate how space in the mural form could be manipulated to produce a questioning of the form itself. Although Herrón would continue to paint important murals by himself and with others, this particular mural made him keenly aware that Chicano art also had to break away from the walls or boundaries created by Chicanos and non-Chicanos alike.

14. Jerry Romotsky and Sally R. Romotsky, *Los Angeles Barrio Calligraphy* (Los Angeles: Dawson's Book Shop, 1976), presents an analysis of the social and aesthetic criteria which separates this particular form of public communication from common vandalizing-type graffiti. See also, Marcos Sánchez-Tranquilino, n.p.

By late 1972, Willie Herrón, Harry Gamboa Jr., Patssi Valdez, and Gronk, as the pioneer Chicano conceptual art performance collective in the United States, were the first to recognize the performative aspect of mural making as an art form in itself. Some of their earliest conceptual art performances continued Herrón's earlier testing of the boundaries of the mural form by using it as the basis for at least two important performances. Towards the end of 1972, the *Walking Mural* went beyond the breaking through of walls found in Willie's earlier mural by having the ASCO members become living elements of murals seeking to free themselves from their formal and cultural restrictions as they walked down Whittier Boulevard, the bustling main commercial artery of East Los Angeles, the heart of the Chicano community. Two years later, in the same area, Gronk fastened Herb Sandoval and Patssi Valdez to an exterior wall with common masking tape two inches wide, thereby creating the *Instant Mural*, bringing into question what constituted a mural. Just as important, it also questioned our own complicity in the perpetuation of boundaries which confine us by exposing their frailty (masking tape).

In both of these examples ASCO questioned the assumed continuing vitality of some painted murals. By exchanging living forms for painted ones in vital areas of social interchange, the *Instant Mural* articulated a concern with the particular effects of continually reviving pre-Columbian and other imagery which could unfortunately become cliché-ridden and prevent the exploration of new conceptual and iconographic territories. Through innovative presentations, ASCO joined other community artists in pointing out the threat of weakening the Chicano community's capacity for cultural self-criticism by the unquestioned continued use of the romantic elements of Chicano nationalist strategies. ASCO's work contributed to a reassessment of the use of pre-Columbian symbols and other icons from Mexican (not Chicano) history in terms of whether they affected the immediate needs of the Chicano community in a positive or negative manner.

At the present time, Chicanos throughout the United States continue to make murals. Although the type of Chicano mural which was created by grass roots organizing is no longer produced, murals by Chicanos articulating a social awareness of that community brought on by the Movement are still being made. In 1984, The Olympics Organizing Committee commissioned several murals for the freeways of Los Angeles of which three were done by Chicanos (*Hitting the Wall* by Judy Baca, *Luchas del Mundo* by Willie Herrón, and *Going to the Olympics* by Frank Romero). That same year the East Los Streetscapers created the *New Fire* mural which connected the 1984 Olympics with a pre-Columbian ritual on a three-story building in the heart of the city. In 1989, Yreina Cervántez created *La Ofrenda*, a city-funded mural administered through the Social and Public Art Resource Center (SPARC) which connected the

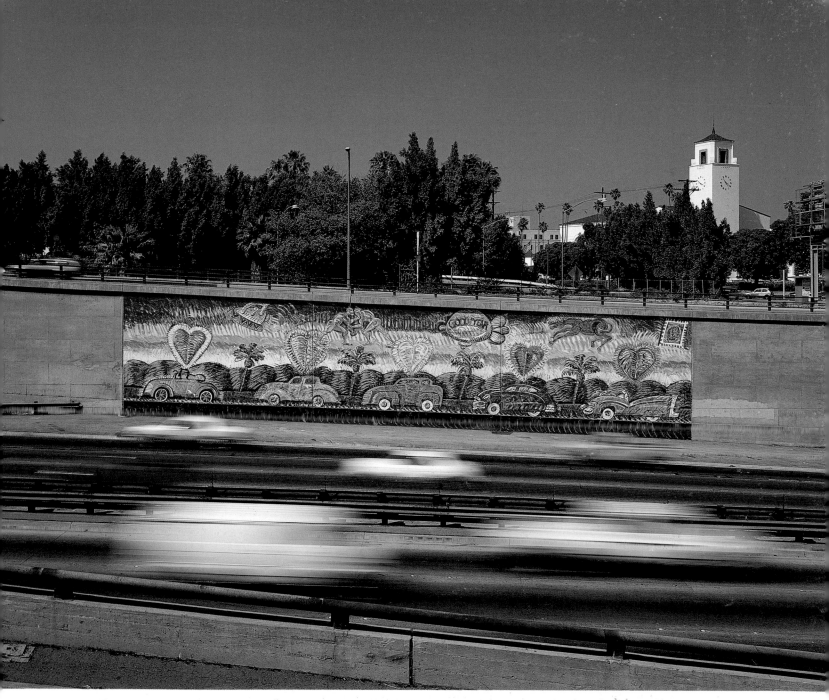

GOING TO THE OLYMPICS
1984
Frank Romero
101 Freeway, Los Angeles
22' x 103'

plight of Central Americans with those of Chicanos by honoring Dolores Huerta, co-founder of the United Farmworkers Union.

Indeed, Chicano artists have changed the focus of their attention over the years according to the social debates which currently affected their community. The content of present-day Chicano murals is nevertheless informed by a cultural and political consciousness developed in the earlier days of the Movement. This is also true for the content of much of Chicano art produced in the studio. Chicano art is currently entering its "appreciation" period as it gains increased acceptance in the larger art market. It is highly valued for the art market as a new source of color, form, imagery and text. However, the understanding of it can only be achieved through analysis of its historical roots and development. Paradoxically, its certified roots (through social art histories) in social resistance will increase its value in the market place. Chicanos, both artists and non-artists, in addition to everyone else in this country, are having to reformulate the contexts of their identities as the demands of living in an increasingly publicly acknowledged multi-cultural society begins to seriously impinge upon hard-earned recent social positionings.

In the wake of the current dismantling of nation-states into new global configurations inspired by the multi-national corporate model, this country's nation-ness, like that of the rest of the "First World" (whether they consider themselves core or periphery nations), is being called into question.[15] Americanization of ethnic minorities in the U.S. is still with us.

The term "Hispanic" is currently the preferred catch-all assignation by the Administration, the media and commercial product advertisers for Chicanos, Puerto Ricans, Cubans, and other Latinos. As such, there promises to be a continuous flurry of new stereotypical imagery from these sectors which attempt to represent this heterogeneous community as a cultural unity. In every case, claims of an assimilated U.S. Hispanic unity will be incorrect. For Chicanos and other Latinos it supposedly signifies that they are no longer to be considered "outside" of the American mainstream. However, by consolidating these diverse group identities without regard to particular contributions by or needs of each group, the term itself becomes one of assignment into a sub-national category.

15. Stuart Hall, "Old and New Identities," recorded lecture delivered 13 and 14 March 1989 at the University Center, State University of New York, Binghamton. See also, Judith McWillie, "The Migrations of Meaning," *Visions, Los Angeles* (Fall 1989): p. 4-5. Citing James Clifford's observation on the present state of increased globalization, "where syncretism and parodic invention are becoming the rule, not the exception, an urban multi-national world of institutional transience — where American clothes made in Korea are worn by young people in Russia, where everyone's 'roots' are in some degree cut — in such a world it becomes increasingly difficult to attach human identity and meaning to a coherent 'culture' or 'language'," McWillie concludes that "mass communications and travel, the ethnic heterogeneity of nations and the acceleration of our planet have made the isolationist programs of previous generations obsolete."

Assimilation through the Hispanic model is a legacy of Americanization efforts inherited from the Nixon administration which sought to replace Johnson's War on Poverty programs with the Office of Minority Enterprise in an effort to "encourage Black and brown capitalism." [16] It represents a process of Americanization by default for the convenience of the administrative and business sectors which tend to traditionally support conservative political and cultural agendas. For Chicanos the term is especially insensitive. For it robs them of the opportunity to acknowledge their indigenous Mexican heritage while it privileges the colonialist European culture of Spain.

The question must remain open whether these sectors, in addition to all of this country's citizens who consider themselves American, can appreciate the legacy of the Chicano Movement in this context: that the Chicano experience represents a model for all Americans to acknowledge their current identity as an outcome of two (or more) living histories coming together; that there is a multiplicity of ways to be American; that the word "Chicano" is an American word (not only an English, or only a Spanish word) because it signifies the unique amalgamation of the old and new identities without the denial of one in favor of the other. That is Chicano; that is American.

Los Angeles
October 1989

16. Rodolfo F. Acuña, *A Community Under Siege: A Chronicle of Chicanos East of the Los Angeles River 1945-1975* (Los Angeles: Chicano Studies Research Center Publications, University of California, Los Angeles, 1984), p. 180.

■ CONTRIBUTORS

■ Holly Barnet-Sánchez is an art historian, one of two project coordinators for the UCLA Wight Gallery's interpretive exhibition of the Chicano art movement: "Chicano Art: Resistance and Affirmation, 1965-85," was an archivist for SPARC's California Chicano Mural Slide Archive, and has lectured and written on Pre-Columbian and Chicano art.

■ Eva Sperling Cockcroft is a muralist, photographer and writer. An author of *Toward a Peoples Art: The Contemporary Mural Movement*, (N.Y.: E.P. Dutton, 1977), she has also written extensively for books and national magazines on mural art, art and society, Latin American and Chicano art.

■ Shifra M. Goldman is an art historian. She teaches at Rancho Santiago College in Santa Ana, California, is a Research Associate with the Latin American Center, UCLA, the author of *Contemporary Mexican Painting in a Time of Change*, and co-compiler of *Arte Chicano, A Comprehensive Annotated Bibliography, 1965-1981*, with Tomás Ybarra-Frausto.

■ Amalia Mesa-Bains is a PhD in psychology, educational consultant to the San Francisco Unified School District, an artist, and the author of several articles dealing with contemporary Chicano cultural representation. She currently is serving as Commissioner of Art for the City of San Francisco.

■ Marcos Sánchez Tranquilino is an art historian, one of two project coordinators for "Chicano Art: Resistance and Affirmation, 1965-85," and was an archivist for SPARC's California Chicano Mural Slide Archive. He has written, lectured, and published on the subject of Chicano art, including the relationships between Chicano murals and Chicano graffiti of the early 1970s.

■ Tomás Ybarra-Frausto teaches Latin American literature, literary theory and Chicano literature at Stanford University. He has written extensively on Chicano cultural production, a a recent publication being *Arte Chicano, A Comprehensive Annotated Bibliography, 1965-1981*, co-authored with Shifra M. Goldman. Currently, he is the Associate Director of Arts and Humanities for the Rockefeller Foundation.

■ LIST OF PLATES

■ SUGGESTIONS FOR FURTHER READING

BOOKS

450 años del pueblo chicano/450 Years of Chicano History in Pictures. Albuquerque: Chicano Communications Center, 1976.

Acuña, Rodolfo. *Occupied America: A History of Chicanos.* New York: Harper & Row, 1988.

Barnett, Alan W. *Community Murals.* Cranbury, NJ: Associated University Presses, 1984.

Barthelmeh, Volker. *Street Murals.* New York: Knopf, 1982.

Barrio, Raymond. *Mexico's Art and Chicano Artists.* Guerneville, CA: Ventura Press, 1978.

Beardsley, John. *Art in Public Places.* Washington, DC: Partners for Livable Places, 1981

Burton, Marie, Holly Highfill, and Mark Rogovin. *Mural Manual.* Boston: Beacon, 1973.

Charlot, Jean. *The Mexican Mural Renaissance, 1920–1925.* New Haven and London: Yale University Press, 1963.

Clark, Yoko and Chizu Hama. *California Murals.* Berkeley: Lancaster-Miller, 1979.

Cockcroft, Eva, John Weber, and James Cockcroft. *Toward a People's Art: The Contemporary Mural Movement.* New York: E.P. Dutton, 1977.

de la Garza, Rodolfo, et al. *The Mexican American Experience: An Interdisciplinary Anthology.* Austin: University of Texas Press, 1985.

de Micheli, Mario. *Siqueiros.* New York: Harry N. Abrams, 1978.

Drescher, Timothy W. *San Francisco Murals, 1914–1990.* St Paul: Pogo Press, 1991.

Dunitz, Robin. *Street Gallery.* Los Angeles: RJD Enterprises (forthcoming 1993).

Edwards, Emily. *Painted Walls of Mexico*. Austin & London: University of Texas Press, 1966.

Garcia, Rupert. *La Raza Murals of California, 1963–1970*. Unpublished master's thesis, University of California, Berkeley, 1981.

Goldman, Shifra M., and Tomás Ybarra-Frausto. *Arte Chicano: A Comprehensive Annotated Bibliography of Chicano Art, 1965–1981*. Berkeley: Chicano Studies Library Publications Unit, University of California, Berkeley, 1985.

Greenberg, David, Kathryn Smith, and Stuart Teacher. *Big Art: Megamurals and Supergraphics*. Philadelphia: Running Press, 1977.

Harris, Moira F. *Museum of the Streets*. St Paul: Pogo Press, 1987.

Hurlburt, Laurance P. *The Mexican Muralists in the United States*. Albuquerque: University of New Mexico Press, 1989.

Levick, Melba (photographs) and Stanley Young (commentaries). *The Big Picture: Murals of Los Angeles*. Boston: Little, Brown, 1988.

McWilliams, Carey. *North From Mexico: The Spanish-Speaking People of the United States*. New York: Greenwood, 1968.

Muñoz, Carlos, Jr. *Youth, Identity, Power: The Chicano Movement*. London: Verso, 1989.

O'Connor, Francis V. *Art for the Millions*. Boston: New York Graphic Society, 1973.

Organista, Ricardo Rico. *The Chicano Mural: Its Analysis and Use for Increasing Cultural Awareness Among Educators*. Unpublished Ed.D. thesis, UCLA, 1983.

Orozco, José Clemente. *Orozco: An Autobiography*. Austin: University of Texas Press, 1962.

Quirarte, Jacinto. *Chicano Art History: A Book of Selected Readings*. San Antonio: Research Center for the Arts and Humanities, 1984.

Quirarte, Jacinto. *A History and Appreciation of Chicano Art*. San Antonio: Research Center for the Arts and Humanities, 1984.

Quirarte, Jacinto. *Mexican American Artists*. Austin: University of Texas Press, 1973.

Redstone, Louis G. and Ruth P. Redstone. *Public Art, New Directions*. New York: McGraw Hill, 1981.

Reed, Alma. *The Mexican Muralists*. New York: Crown, 1960.

Ríos-Bustamente, Antonio and Pedro Castillo. *An Illustrated History of Mexican Los Angeles, 1781–1985*. Los Angeles: Chicano Studies Research Center Publications Monograph #12, University of California, Los Angeles, 1986.

Rodríguez, Antonio. *A History of Mexican Mural Painting*. New York: G.P. Putnam, 1969.

Siqueiros, David Alfaro. *Art and Revolution*. London: Lawrence & Wishart, 1975.

Siqueiros, David Alfaro. *Cómo se pinta un mural*. Cuernavaca: Ediciones Taller Siqueiros, 1977.

Sommer, Robert. *Street Art*. New York: Links Books, 1975.

Stein, Philip. *The Mexican Murals*. Mexico City: Editur, 1984.

Tibol, Raquel. *Siqueiros Vida y Obra*. Mexico: Colección Metropolitina, 1973.

Valdez, Luis and Stan Steiner, eds. *Aztlán: An Anthology of Mexican American Literature*. New York: Vintage, 1972.

Wolfe, Bertram D. *The Fabulous Life of Diego Rivera*. New York: Stein and Day, 1963.

CATALOGS/JOURNALS

Aguilar, John, Shifra Goldman, and Tomás Ybarra-Frausto. *Chicano Aesthetics: Rasquachismo*. Phoenix: MARS, Inc., 1989.

AZTLÁN: Chicano Journal of the Social Sciences and the Arts. Los Angeles: Chicano Studies Research Center, University of California, Los Angeles, 1970–present.

The Barrio Murals. Exhibition catalog with essays by Mark Rogovin and Victor Sorell. Chicago: Mexican Fine Arts Center-Museum, 1987.

Beardsley, John, and Jane Livingston. *Hispanic Art in the United States: Thirty Contemporary Painters and Sculptors.* New York: Abbeville Press, 1987.

Brookman, Philip, and Guillermo Gómez-Peña, eds. *Made in Aztlán: Centro Cultural de la Raza, Fifteenth Anniversary.* San Diego: Centro Cultural de la Raza, 1986.

Chicano Expressions: A New View in America. New York: Intar Latin American Gallery, 1986.

Community Murals Magazine, 1978–88. Available from CMM, 1019 Shattuck Avenue, Berkeley, CA 94707.

Garcia, Rupert. *Raza Murals and Muralists: An Historical View.* San Francisco: Galería de la Raza, 1974.

Griswold del Castillo, Richard, Teresa McKenna, and Yvonne Yarbro-Bejarano. *Chicano Art: Resistance and Affirmation 1965–1985.* Los Angeles: Wight Art Gallery, UCLA, 1991.

Martínez, Santos G., Jr., ed. *Dále Gas / Give it Gas.* Houston: Contemporary Art Museum, 1977.

Mesa-Bains, Amalia, and Tomás Ybarra-Frausto. *Lo del corazón: Heartbeat of a Culture.* San Francisco: The Mexican Museum, 1986.

Mesa-Bains, Amalia, and Ray Patlán. *Social History Through Murals.* San Francisco United School District, 1988.

Moore, Sylvia, ed. *Yesterday and Tomorrow: California Women Artists.* New York: Midmarch Arts Press, 1989.

O'Connor, Francis B. *Diego Rivera: A Retrospective.* Detroit: The Detroit Institute of Arts, 1985: 157–83.

Quirarte, Jacinto. *17 Artists: Hispano, Mexican American, Chicano.* Chicago: Illinois Bell, 1976.

Raíces Antiguas, Visiones Nuevas / Ancient Roots, New Visions, curated by Marc Zuver and Rebecca Kelley Crumlish. Tucson, AZ: Tucson Museum of Art, 1977.

Sin Fronteras, Crossing Borders: Mexican American Artists in the Southwest. Colorado Springs: The Gallery and the University of Colorado, 1989.

Sorell, Victor A., ed. *Guide to Chicago Murals: Yesterday and Today.* Chicago: Chicago Council On Fine Arts, 1979.

Walking Tour and Guide to the Great Wall of Los Angeles. Venice: Social and Public Art Resource Center, 1983.

Wolfe, Bertram D. *Diego Rivera: A Retrospective.* New York and London: Founders Society of Detroit Institute of Art in association with W.W. Norton, 1986.

World Wall. Venice: Social and Public Art Resource Center, 1992.

ARTICLES

Ahlander, Leslie Judd. "Mexico's Muralists and the New York School," *Americas* 31:5 (May 1979): 18–25.

Benavidez, Max, and Kate Vozoff. "The Wall: Image and Boundary, Chicano Art in the 1970s," in Leonard Falgarait, ed., *Mexican Art of the 1970s: Images of Displacement.* Nashville: Vanderbilt University, Center for Latin American and Iberian Studies, 1984, 45–54.

Burciaga, José Antonio. "Mural Protest," *Chisme-Arte* 1:1 (Fall 1976): 27–28.

"The California Murals," *Artweek* 23:13 (April 9, 1992): 5–23.

Castellanos, Leonard. "Chicano Centros, Murals and Art," *Chisme-Arte* 1:1 (Fall 1976): 26–29.

"The City Is Their Canvas," *City* (May–June 1971): 38–40.

■ INDEX

Boldface indicates photographs.
Italics indicate murals and works of art.

Index prepared by Eric A. Gordon.